MYSTIC BONES

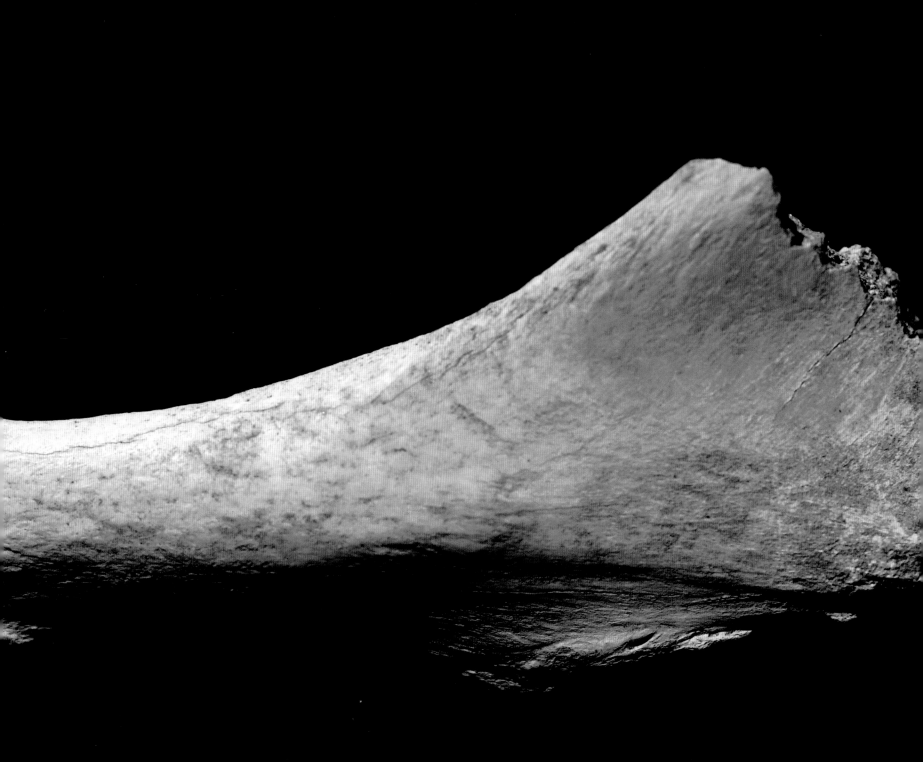

MYSTIC BONES

MARK C. TAYLOR

THE UNIVERSITY OF CHICAGO PRESS

Chicago and London

MARK C. TAYLOR is professor of humanities at Williams College. Among his many books are, most recently, *Confidence Games: Money and Markets in a World without Redemption* and *The Moment of Complexity: Emerging Network Culture*, both published by the University of Chicago Press.

The University of Chicago Press, Chicago 60637
The University of Chicago Press, Ltd., London
© 2007 by The University of Chicago
All rights reserved. Published 2007
Printed in the China
16 15 14 13 12 11 10 09 08 07 1 2 3 4 5

ISBN-13: 978-0-226-79037-4 (cloth)
ISBN-10: 0-226-79037-1 (cloth)

Library of Congress Cataloging-in-Publication Data

Taylor, Marc C., 1945–
 Mystic Bones / Mark C. Taylor.
 p. cm.
Includes bibliographical references.
ISBN-13: 978-0-226-79037-4 (cloth : alk. paper)
 1. Oracle Bones.
 2. Divination.
 3. Deserts — Nevada — Pictorial works.
 4. Paiute Indians — Religion.
 5. Indians of North America — Nevada — Religion.
 I. Title.
BF1891.B64T39 2007
203'7 — dc22 2006016061

FOR
ALAN THOMAS

RUBBINGS
OF
REALITY

So much begins in the desert. A place of exile and wandering, of temptation and tribulation, the desert is haunted by absence and loss. The specter of death stalks you in the desert. It is not just the danger of losing your way in trackless terrain or the threat of thirst; it is a different peril all the more ominous because it is so elusive. In the desert, the unnamable approaches without ever arriving. You cannot know yourself until you venture into the desert *alone*, and then you learn that to find yourself is to lose yourself.

This is a lesson that the late poet Edmond Jabès taught me many years ago. One afternoon during a long conversation in his apartment on Epée de Bois, he spoke, as he rarely did, about silence. Reflecting on his life in Cairo before events forced him to move to Paris, Jabès began by reciting lines he had written in *The Book of Margins*.

> God's truth is in silence
>> To fall silent in turn, with the
> hope of dissolving into it.
>> But we become aware of it only
> through words.
>> And words, alas, drive us ever far-
> ther from our goal.[1]

Here lies the paradox of an art that can never be called our own: silence can be heard only through the words that destroy it. In today's world people do not have

time for silence and thus they have forgotten God even though — or perhaps because — we hear this name more than ever.

As dusk fell and our conversation neared its end, Jabès approached the point toward which he seemed to have been moving his entire life. Rising in his chair, he became animated and spoke with an intensity I rarely have heard: "It is very hard to live with silence. The real silence is death and this is terrible. To approach this silence, it is necessary to roam in the desert. You do not go into the desert to find identity but to lose it, to lose your personality, to become anonymous. You make yourself void. You become silence. You must *become* more silent than the silence that surrounds you. And then something extraordinary happens: you hear silence speak." To hear silence speak, I have since learned, is to see the world differently. In that moment, the desert is transformed from the space of death to the place of life.

A decade later, I went into the desert with Jabès' words and their silence haunting me. It was not the Sahara Desert of Jabès' memory but the desert of the American West. Having agreed to write an essay on Michael Heizer's influential earthwork *Double Negative*, I planned to spend several days with Heizer at his home in the middle of the Nevada desert, 120 miles north of Las Vegas. Though I did not realize it at the time, there are few better places to begin a journey to the desert than the glitzy capital of faux. The road out of Vegas leads from the desert of the real to the real of the desert.

Heading north from Las Vegas, you gradually ascend from the low to the high desert, until the highway suddenly turns to the right and cuts through a narrow pass. Here the richly colored and intricately convoluted basalt cliffs are covered with designs that bear no trace of a human hand. As the road bends again to the left, a lake and dense marsh appear like a mirage tempting the weary traveler. After twisting and turning through the narrows carved from archaic stone, the road drops into the lush Pahranagat Valley, where a string of lakes,

marshes, and swamps serve as stopping place and home to countless species of birds. The brilliant greens of the valley enrich the delicate browns, reds, grays, and yellows of the surrounding land, reeducating eyes whose vision has been dulled by the lights of cities.

The narrows that form the entrance to Pahranagat (Paiute for "walking man") Valley mark the southern perimeter of the Great Basin. To pass through this gap is to enter a unique space by journeying back to a time so ancient that it is beyond human memory. The desert is the place of time immemorial, time outside of time, time that can never be recollected, time whose silence cannot be broken. This time is never present, nor is it absent; rather, it approaches by withdrawing. *Desert*, after all, is a verb as well as a noun. To desert is to withdraw, leave, forsake, abandon. Desert … deserting: What withdraws? Who forsakes? What abandons? Who is abandoned—and to what?

More than 100 miles north of Vegas, an unmarked dirt road heads westward into the desert. For much of the year, this road is impassable, and even in good weather rocks, ruts, and dust make driving precarious. If you manage to negotiate this road through what most people regard as barren wasteland, a world of austere beauty opens before you. But such a journey takes time, more time than we ever seem to have. Time as long as life itself, perhaps even longer.

The entrance to Garden Valley is a narrow gap that once was the plug that prevented the waters of this ancient basin from draining to the distant sea. The mountains bordering the basin are rippled, ribboned, and laminated. In the desert, surfaces become profound. These shifty rocks sustain a vital tension, like massive works of an anonymous sculptor, pitched in such a way that it remains unclear whether they are ascending or descending. On the surface of these formations, land and sky stage a performance in which they constantly reflect each other. Purple shadows cast by clouds pattern the valley like paint on the surface of a stretched canvas. The farther I drove, the more I began to understand why

Heizer had chosen to create his earthworks in the desert. Cooperating rather than competing with the land, his work shows us that all art is a moment in a work of art that is infinite.

In this land where distance is measured by the size of dust clouds, stray cattle and herds of wild horses roam where prehistoric water monsters once swam. Golden eagles soar with a grace that belies their deadly purpose. Occasional sheep suggest the passing presence of Basque herders whose flocks have grazed these valleys almost as long as miners have probed the hills. The character of the Nevada ranges is as different from eastern mountains as the people who live in their midst. Time has not yet had its corrosive effect. In the East, refinement wears down by wearing away; in the West, the land and the people have not lost their rough edges; elements are more elemental and fashion less fashionable. What does not wear well does not last long. This does not necessarily mean that things are more direct and literal or less elusive and subtle. To roam in the desert is to glimpse the opaque transparency of a light whose clarity renders it obscure.

Evidence of human life in Garden Valley can be found as far back as 9000 BCE. While the earliest inhabitants of this area were probably from the Western Pluvial Lakes and Desert Archaic traditions, evidence suggests that the Southern Paiute and Shoshone peoples were already in the basin by 700 BCE. One of the most intriguing aspects of Garden Valley is a rock shelter, discovered in 1976 by Heizer and his father, Robert, who was a well-known anthropologist. Perched on a rock outcropping overlooking the valley, this cave was formed in the Tertiary Age. Investigation of the site has unearthed projectiles dating from 6400 BCE and over 350 pottery fragments from later periods. From 700 BCE to 1085 CE, the Shoshone and Southern Paiute used it as a base camp for their hunting and gathering expeditions.

Petroglyphs scattered throughout the area provide additional evidence of the activities of early Native Americans. While the precise function of so-called rock

art remains the subject of heated debate, there is growing evidence to suggest that petroglyphs were intended to serve a very practical function. According to Robert Heizer and Martin Baumhoff, "most Nevada petroglyphs have 'meaning' in terms of one of the hunting patterns of the prehistoric inhabitants of the state.... The most reasonable assumption ... is that the glyphs themselves, or the act of making them, were of magico-religious significance, most probably a ritual device to insure the success of the hunt. The recent Great Basin tribes did not use petroglyphs as hunting magic and, in fact, deny having made them for any reason. At the same time, shamanistic rituals connected with the hunting of deer, antelope or mountain sheep are widely practiced throughout the Great Basin. Since the petroglyphs are evidently connected with hunting, and since they had no real influence on the game (although they may have had psychological influence on the hunters), it is most likely that they were of ritualistic importance."[2] The ritualistic use of petroglyphs should not obscure their artistic value. In this early stage of human development, religion and art were inseparable. Ranging from the representative to the abstract, the petroglyphs scattered throughout the valley display the spare elegance that has attracted so many of the greatest modern artists. Will today's art last as long as the work of these anonymous artists?

During my stay in the desert, I spent quite a bit of time wandering alone. Solitude, I have learned, is not the same as isolation. Isolation separates, solitude connects. We seek isolation to get away from it all; we seek solitude to relate to it all. When solitude is essential, the all to which we relate is inhuman as well as human. The draw of the desert is something that surpasses our humanity. Paradoxically, we are most together when we are most alone because solitude is what we finally share. But solitude does not come easily—if it comes at all. It requires patience to linger and listen to the quiet rustling that the din of the everyday usually drowns out. Solitude and silence are inseparable.

No time is more silent in the desert than high noon. It is as if night and day were reversed. At night the desert cools and comes to life. If you sit quietly, you can hear the scurrying and scampering of creatures you cannot see. But in the bright light of day, everything is still and silent. Indeed snakes and lizards can die if exposed to noonday sun for merely ten minutes. In the middle of the day it seems as though nothing moves, or, perhaps, that the only thing moving is nothingness itself. Shadows give way to a shimmering clarity that is surreal. In this light, beauty appears more subtle than truth.

As I roamed, I was fascinated by countless bones that testified to lives the desert had consumed. Some I could identify—cattle, horse, sheep, deer, jackrabbit, pack rat, rattlesnake—many I could not. I found these bones strangely attractive and collected a few to take back east with me. All the bones I gathered were the remains of cattle: three jaws with teeth, one scapula, and one vertebra. Though I knew cows and bulls are sacred in many myths and religious traditions, I did not realize at the time that jaws, scapula and vertebrae have special significance. In some traditions, the jaw is believed to be the seat of the animal's soul, the scapula inspires divination, and vertebrae are used to make necklaces for cults and rituals. When I showed the bones to Heizer, he immediately saw them as works of sculpture. The day before I left, we fashioned the three jawbones into a work of art that still hangs in our living room beside grave rubbings I have made over the years.[3]

For more than a decade the shoulder bone and vertebra sat in my study. I saw them every day and spent more time thinking about them than I would like to admit. My fascination, I discovered, was anything but morbid. What drew me to these bones was their remarkable *beauty*. It seemed undeniable to me that they were works of art without an artist. Though my interest grew, I did not know where it would lead. I suspected, however, that if I listened long enough the bones would tell me what to do with them. Finally, an answer came; early one morning I heard them whisper, "Photograph us!" I had done quite a bit of photography

when I was young but for years had made nothing more than snapshots. In the interim, digital replaced chemical photography, and I had no experience with the new technology. I decided, therefore, to solicit the assistance of a gifted young photographer, Kevin Reilly, who taught me how to use a digital camera. The initial images astonished me and having seen them, I knew I had only begun. Now I needed more bones.

Uncertain where to buy bones, I searched the Internet and found a company in New Mexico that sells cattle skulls. A few days later FedEx delivered my order. When I unpacked the box, I found a perfectly shaped skull, which had been scrubbed clean and bleached, with horns that had been polished till they shined. I quickly set about photographing the skull, but the results were disappointing. The images were crisp but no matter what I did they had no character. I finally concluded that the bones were too clean. The textures and colors that made them beautiful had been washed away with the dirt. I needed bones that still carried the dust and sand of the desert. Knowing that dirty bones would be hard to find even on eBay, I turned to a friend who has a ranch in Wyoming, and asked if his hands might be able to collect some bones for me. And I asked specifically if they could find cattle, deer, and elk bones, not only because they are common in Wyoming but, more important, because they are sacred in a number of spiritual traditions throughout the world.

Several months later, my friend's secretary called from New York to tell me the bones had arrived. When I finally caught up with them, I was overwhelmed. There were two big boxes crammed full of bones of all shapes and sizes: skulls, jaws, legs, hips, pelvises, ribs, teeth. And best of all, they were all dirty. Earth, sand, moss, lichen, fur, even flecks of flesh lent the bones an uncanny beauty. I now had more than enough material to begin photographing again.

As I worked with more than 1200 images of bones photographed from every conceivable angle and in every imaginable light, the forms became more and more intriguing. Many of the images were virtually unrecognizable as bones. It

was as if the bones came to life under the eye of the camera. Far from isolated objects, the solitary bones radiated colors they had absorbed from the land. Their curves and textures bore traces of the elements that had so carefully sculpted them. Figures bordering on the sublime act as a lure for the imagination. I found it irresistible to seek resemblances in the images of these bones: deserts, landscapes, rocks, trees, forests, lakes, streams, rivers, capillaries, nerves, hands, feet, faces. These were mystic bones, rubbings of reality we can never escape. I suspect the Paiute and Shoshone in Garden Valley already knew this long ago.

LIVING BONES

For organisms classified in the phylum Chordata, there is no life without bones. Bones literally support life; they are the skeleton of Being. The articulation of the skeleton defines the architecture of the body. Bone, however, develops only gradually. In the beginning, it's all a matter of skin. After the fertilization of the ovum, cells first multiply and then divide to create a hollow ball called a blastula. This sphere eventually invaginates to form a lined pocket consisting of two layers known as the endoderm and ectoderm, which, in turn, partially peel away to create a third surface named the mesoderm. The entire mature organism develops from these three dermal layers. The endoderm forms the blood, internal organs, and all interior linings; the mesoderm produces the skeleton, connective tissue, muscles, and the urogenital and vascular systems; and the ectoderm engenders the hair, nails, and epidermis. In his classic *On Growth and Form*, D'Arcy Wentworth Thompson explains the implications of the embryological development of bones: "The skeleton begins as a *continuum*, and a *continuum* it remains all life long. The things that link bone with bone, cartilage, ligaments, membranes, are fashioned out of the same primordial tissue, and come into being *pari passu* with the bones themselves. The entire fabric has its soft parts and its hard, its

rigid and its flexible parts; but until we disrupt and dismember its bony, gristly and fibrous parts one from another, it exists simply as a 'skeleton,' as one integral and individual whole."[4] The process of bone formation is known as ossification.[5] Throughout life there is an ongoing struggle between formation and deformation, or growth and decay. While osteoblasts make new bone to maintain the skeletal structure, osteoclasts destroy and reabsorb bone. Ossification begins during the third month of fetal development and ends during adolescence. Bones are created either from cartilage or fibrous membranes consisting of collagen and blood vessels. Once bones are formed, they can be refined and reshaped by osteoclasts, which act like microsculptors on inner and outer surfaces. During the early years of life, bone production outpaces destruction and in the latter part of life the process is reversed, making bone less flexible and more brittle.

Though firm enough to resist dissolving in bodily fluids and to support the body, living bones have a highly plastic structure, which increases their strength. Long-time surgeon Richard Selzer captures the vitality of bones: "Stony and still though it seems, bone quickens; it flows. It is never the same at any two moments. The traverse of calcium from the blood to the bone and back again is a continuous thing, which ceaseless exchange of mineral is governed by hormonal potentates from glands afar. Fluid, too, is pressed into, then extracted from, the bone in a never-ending current, yet slow as Everglade."[6] In addition to protecting essential organs, one of the most important functions of bones is to make blood cells. The red bone marrow produces one trillion red blood cells every day and releases them into the circulatory system. It is possible to determine the overall health of an organism by the condition of bone marrow.

The internal architecture of bones is as intricate as their external topography. The deeper one probes, the more canals and caverns open. This structure has evolved to facilitate the circulation of blood and to channel fluids derived from blood that nourish bone tissue. The shafts, or diaphyses, of long bones are formed

from compact bone, which surrounds an intricate arrangement of microscopic ducts known as the haversian system or osteron. In most cases, the haversian system is organized around a central canal with many lacunae and intricate networks of tiny crevices and branches. Far from a closed structure bone is a complex network that is open at every level. Like canyon walls etched over the centuries by rushing water, bone bears the traces of flows coursing through them.

The other programmatic requirement governing the architecture of bones is the capacity to bear significant weight. One cubic inch of bone can withstand the impact of two tons. To create this impressive strength, mineral crystals wrap around the collagen fibers to form material with great load-bearing capacity. The collagen fibers retain enough elasticity to add high tensile strength. But it is the structure as much as the substance that produces the strength of bone. It is as if the geometry of the latticework or cancelli were designed by a crafty engineer who knows the precise angles and vectors necessary to maximize strength. Form follows function in lines and shapes that integrate beauty and practical efficacy.

The strength of bones is also evident in their endurance. In the end, it all comes down to the matter of bones. Bones are what remain—what remain of the remains. Even when bodies are consumed in sacrificial fires and funeral pyres, bones or their fragments are left over. One of the many paradoxes of bones is the way they embody a disturbing coincidence of the personal and the impersonal. Nothing is closer to us than our bones; indeed, bones are the substance of our very being, and for those who know how to read them, bones tell stories of the lives they once supported. With nothing more than the smallest fragment or even traces of ash, forensic detectives and anthropologists can unravel mysteries ancient and recent. Most of what we know about our prehistoric ancestors we have learned from bones. The way individuals and groups dispose of bones—animal as well as human—reveals much about the life of a society and its culture.

And yet, for all their individuality and idiosyncrasy, there is something terrifyingly anonymous about bones. Bones allow silence to speak through their anonymity. Instead of recalling the life they once bore, bones tend to memorialize oblivion. It is not the cessation of life but its forgetting that renders death final. The bones of others prefigure the unavoidable nothingness awaiting us. The dread of nothing, however, does not diminish the beauty of bones. To the contrary, anonymity harbors an inhuman beauty that is greater than anything merely personal. If our humanity can ever be found, perhaps it is by losing it in this inhuman beauty.

SACRED BONES

Throughout much of human history, bones have been associated not with death but with life. In many cultures, people actually believe bones are the seat of the vital principle or even the soul. As the locus of life, bones have mystic powers ranging from cure and divination to birth and rebirth. In the Hebrew bible, Eve is born from Adam's rib: "bone from my bones" (Genesis 2:21–22). In other biblical texts, bones appear to be conscious and even able to speak. The Psalmist declares

My very bones cry out,
"Lord, who is like thee?—
thou savior of the poor from those too strong for them,
the poor and wretched from those who prey on them."
(Psalm 35:10–11)

The most important and widely held belief is that bones can be reanimated and therefore are essential to rebirth. This conviction is especially common among

people in northern Eurasia as well in parts of Asia and can also be found in the myths of Germany, the Caucasus, Africa, South America, Oceania, and Australia. Ancient civilizations in Iran, Egypt, Mesopotamia, and Ugarit also believed in the reanimation of bones.[7] One of the most remarkable accounts of the resurrection of bones appears in the book of Ezekiel.

> The hand of the Lord came upon me, and he carried me out by his spirit and put me down in a plain full of bones. He made me go to and fro across them until I had been round them all; they covered the plain, countless numbers of them, and they were very dry. He said to me, "Man, can these bones live again?" I answered, "Only thou knowest that, Lord God." He said to me, "Prophesy over these bones and say to them, O dry bones, hear the word of the Lord. This is the word of the Lord God to these bones: I will put breath into you, and you shall live. I will fasten sinews on you, bring flesh upon you, overlay you with skin, and put breath in you, and you shall live; and you shall know that I am the Lord." I began to prophesy as he had bidden me, and as I prophesied, there was a rustling sound and the bones fitted themselves together. As I looked, sinews appeared upon them, flesh covered them, and they were overlaid with skin, but there was no breath in them. Then he said to me, "Prophesy to the wind, prophesy, man, and say to it, These are the words of the Lord God: Come, O wind, come from every quarter and breathe into these slain that they may come to life." I began to prophesy as he had bidden me: breath came into them; they came to life and rose to their feet. (Ezekiel 37:1–10)

Where there is belief in reanimation, bones are often preserved after the flesh has decayed and are treated with special care. In some cases, they are given a separate burial or are preserved as objects of worship.

It is not only human bones that are surrounded with an aura of sacrality, but often the bones of certain animals as well. Joseph Beuys, whose influential

art draws upon and even reenacts spiritual traditions many regard as primitive, explains the abiding significance of animals: "Why do I work with animals to express invisible powers?—You can make these energies very clear if you enter another kingdom that people have forgotten, and where vast powers survive as big personalities. And when I try to speak with the spiritual existences of this totality of animals, the question arises of whether one could not speak with these higher existences too, with these deities and elemental spirits."[8] Though many animals have been venerated over the years, three of the most important are cattle, deer, and elk. The myths and rituals associated with a variety of animals are remarkably consistent. Beuys continues, "There are many proscriptions against breaking or in any way harming the bones of animals (especially bears, reindeer, and other animals which are hunted); such bones are to be carefully collected and disposed of. They are buried, or exposed in trees or on platforms, or wrapped in the bark of trees or covered with stones, brush, and so on. Such practices are attested especially for northern Eurasia and North America."[9]

As always, taboos are symptomatic of latent desires. The relations between humans and animals are fraught with ambiguity and ambivalence. Animals embody what is both high and low and, thus, they are simultaneously attractive and repulsive. Insofar as the animal is deemed divine, it is that which is most real and most highly valued. In many traditions, however, "the animal" also represents that over against which "the human" defines itself. The presence of the animal reminds us of what we once were and never again should become. To be fully human, our "animal" instincts must be controlled, if not eliminated. This ambivalence toward animals is acted out in sacrificial rituals where prohibitions that usually protect animals are temporarily suspended. Even when it is not obvious, sacrifice harbors remnants of blood sacrifice. For the psychologist, ritual violence reestablishes intrapersonal equilibrium by displacing hostility toward the father onto a substitute; for the sociologist, sacrifice of the totem animal restores social

cohesion by allowing the release of interpersonal tensions. Whether individual or social, the logic of sacrifice involves a paradoxical affirmation by negation and negation by affirmation. In the act of murder, one identifies with the god through which one hopes to transcend the very animal instincts that issue in sacrificial violence. As eros and thanatos mingle in spilt blood, agent and victim become one. Primitive rites persist in contemporary rituals.

> In truth, in the very truth I tell you, unless you eat the flesh of the Son of Man and drink his blood you can have no life in you. Whoever eats my flesh and drinks my blood possesses eternal life, and I will raise him up on the last day. My flesh is real food; my blood is real drink. Whoever eats my flesh and drinks my blood dwells continually in me and I dwell in him. As the living Father sent me, and I live because of the Father, so he who eats me shall live because of me. This is the bread which came down from heaven; and it is not like the bread which our fathers ate: they are dead, but whoever eats this bread shall live forever. (John 6:52–58)

Evidence of the veneration of animals dates back to the beginning of human history. Animals are the primary figures in the rock paintings usually executed in caves and caverns by hunting tribes during the Paleolithic era (c. 30,000–10,000 BCE). André Leroi-Gourham, the leading authority on cave art in Paleolithic Europe, writes: "Paleolithic artists did not portray just any animal, but animals of certain species, and these did not necessarily play a part in their daily life.… The main actors are the horse and the bison, the animals next in importance being the hinds, the mammoths, the oxen, the ibexes and the stags.… Bears, lions, and rhinoceroses play an important part, but as a rule there is only one representation of each per cave, and they are by no means represented in every cave."[10] The most remarkable prehistoric paintings are in the cave of Lascaux in southwest France. In a complex of underground caverns as impressive as any Gothic ca-

thedral, images of reindeer, bulls, bison, horses, and imaginary animals create a fabulous world that is at once startling and humbling. The sophistication of the figures and delicacy of their colors—browns, yellows, ambers, siennas, reds, white, black—rival the work of modern and contemporary artists. Georges Bataille went so far as to call Lascaux the birthplace of art. If art began in Lascaux, it had not yet been distinguished from religion. Indeed, it is precisely their spiritual significance that lends these figures their distinctive force. The darkness of the cave, Bataille avers, "illumines the morning of our immediate species." "At Lascaux, more troubling even than the deep descent into the earth, what preys upon and transfixes us is the vision, present before our eyes, of all that is most remote. The message, moreover, is intensified by an inhuman strangeness. Following the rock walls, we see a kind of cavalcade of animals.... But this animality is nonetheless *for us* the first sign, the blind unthinking sign and yet the living intimate sign, of *our* presence in the real world."[11] The scale of the figures is as impressive as their complex simplicity. The paintings of bulls and deer range from seven to eighteen feet. From the caves of Lascaux to the petroglyphs of Garden Valley, the unity of religion and art is etched in stone.

Since the time of roaming tribes and ancient empires east and west, people have worshipped cattle. Indo-Aryans or Vedic Aryans brought the sacrifice of cattle to India in the second millennium BCE. "The slaughter of animals," D. N. Jha explains, "formed an important component of the cult of the dead in the Vedic texts. The thick fat of the cow was used to cover the corpse and a bull was burnt along with it to enable the departed to ride in the nether world."[12] By the time of the *Ṛgveda*, the cow had become sacred and both milk and milk products were used in important religious rituals. In other traditions, the bull is more important than the cow. In Egypt during the reign of the pharaohs, for example, cults formed around sacred bulls believed to have oracular powers. Particularly powerful bulls were mummified and accorded elaborate burial ceremonies. As

myths and rituals drifted westward, worship of the bull eventually influenced the practices of early Christians in ways that are rarely noted. In his monumental novel *The Recognitions*, William Gaddis goes so far as to suggest that Christianity is actually a pale copy of the more powerful and original Mithraism. During the first millennium BCE, Mithraism, which arose in Persia, extended from Asia Minor and Babylon and Armenia. By the early centuries of the Christian era, it had spread throughout the Roman Empire and for a brief time posed a threat to the expansion of Christianity. Traditionally identified as a solar deity who battles the powers of darkness embodied in the figure of the bull, Mithra was known as Tauroctonus (bull slayer). The death of the bull regenerates life and turns the tide in the annual struggle against the powers of darkness. Followers of Mithra ritually repeated the sacrifice of the bull in an underground cavern called the Mithraeum, where the slain bull was butchered and eaten during a communal meal. As the appeal of Mithraism began to fade, Christians took over the Mithraea and used them for conducting services. Early Christianity shared more than space in Mithraism — the Eucharist obviously bears unmistakable traces of the Mithraic ritual.

Ancient Greek religion reversed the order of substitution: rather than the human substituting for the animal as in Christianity, the animal is substituted for the human. According to the general rule of sacrifice, the value of a gift is directly proportionate to its worth for the owner. The practical value of cattle made them one of the most precious offerings the Greeks presented to their gods. By the time Euripides wrote the *Bacchae* (920 BCE), the bull had been sanctified and was associated with the powerful and influential Dionysus, also known as Bacchus, god of wine and inspiration, who was worshipped in orgiastic rites. In Greek religion, animal sacrifice eventually gave way to the offering of precious metals that first took the form of small statuettes of the sacrificial animal and later coins bearing the image of the animals. Echoes of this ancient practice can

be heard in the word *pecuniary*, which derives from the Latin *pecus*, which means cattle. The first mints were actually Greek temples. The offering of money to God is a ritual that can be traced to the sacrifice of cattle.

As these practices suggest, the complicated relations between animals and humans are at least in part economic. Human beings have tended to worship animals, whether domestic or wild, upon which they depend and from which they expect benefits. For the aboriginal people who lived on the Northern Plains and Plateau, which includes the area where most of the bones in these photographs were gathered, the success of the hunt depends on deer and elk *allowing* themselves to be killed. Animals were believed to communicate with people through dreams in which they direct hunters to herds and instruct them about ways to maintain the balance necessary to sustain life. In some traditions, adolescents undertook a quest for a guardian spirit who appears in a vision as a sacred animal. This practice was particularly common among the Northern Paiutes who lived in Garden Valley, where the devotion to animals like deer and elk expressed itself in the veneration and protection of their bones. To mistreat the bones was to abuse the animal and thus to upset the relation upon which life depends. Sir James Frazer points out that Native Americans treated deer and elk with "punctilious respect." "Their bones," he explains, "might not be given to the dogs nor thrown into the fire, nor might their fat be dropped upon the fire, because the souls of the dead animals were believed to see what was done to their bodies and to tell it to the other beasts, living and dead. Hence, if their bodies were ill-used, the animals of that species would not allow themselves to be taken, neither in this world nor in the world to come."[13]

All bones, however, are not created equal. In different traditions, skulls, vertebrae, and shoulder blades (scapulae) are believed to harbor special powers that lend them ritual significance. The conviction that bones are living leads to the belief that they can communicate. One of the bones used widely in divination

is the scapula. The practice of scapulomancy (also known as spatulamancy) is a form of divination that involves studying the pattern of cracks and fissures in bones that have been heated over an open fire. Though it dates back to ancient Babylon and is still practiced from Asia and India to Europe, one of the most intriguing instances of scapulomancy is practiced by the Montagnais-Naskapi on the Labradorean Peninsula in North America. Omar Moore describes the ritual.

> Animal bones and various other objects are used in divination. The shoulder blade of the caribou is held by them to be especially "truthful." When it is to be employed for this purpose the meat is pared away, and the bone is boiled and wiped clean; it is hung up to dry, and finally a small piece of wood is split and attached to the bone to form a handle. In a divinatory ritual the shoulder blade, thus prepared, is held over hot coals for a short time. The heat causes cracks and burnt spots to form, and these are then "read." The Naskapi have a system for interpreting the cracks and the spots, and in this way they find answers to important questions. One class of questions for which shoulder-blade augury provides answers is: What direction should hunters take in locating game? This is a critical matter, for the failure of a hunt may bring privation or even death.[14]

Cracks in bones, it seems, are hieroglyphs for those who know the code. The Montagnais-Naskapi read in the fissures the topography of the territory where they hunt. As we will see, it is possible that there are other codes with which to read the messages etched in bone.

The use of bones for divination is a common part of many shamanistic rituals. Shamanism is, as Mircea Eliade calls it, an "archaic technique of ecstasy." Since bones can be reanimated, they play a critical role in the ritual of the death and rebirth of the holy man. Eliade describes a pattern that is found in several cultures.

The skeleton present in the shaman's costume summarizes and reactualizes the drama of his initiation, that is, the drama of death and resurrection. It is of small importance whether it is supposed to represent a human or an animal skeleton. In either case what is involved is the life-substance, the primal matter preserved by the mythical ancestors. The human skeleton in a manner represents the archetype of the shaman, since it is believed to represent the family from which the ancestral shamans were successively born.... A similar theory underlies the cases in which the skeleton—or the mask—transforms the shaman into some other animal (stag, etc.). For the mythical animal ancestor is conceived as the inexhaustible matrix of the life of the species and this matrix is found in these animals' bones. One hesitates to speak of totemism. Rather, it is a matter of mystical relations between man and his prey, relations that are fundamental for hunting societies.[15]

To complete the process of rebirth, the initiate must experience a mystical vision in which he first imagines his body stripped of its flesh and then names and numbers his own bones. The shaman cannot experience rebirth until he "becomes" his skeleton.

Nowhere is the ritual use of bones more important than in Tibetan Buddhism, where human skulls play a critical role in Lamaist ceremonies. There is considerable evidence suggesting that these customs were adapted from Indian practices in which Shiva as Kāpalabhrta or Mahakals, the Great Destroyer, is frequently depicted wearing a wreath of human skulls as a necklace. In the Prabodha Chandrodaya, performed in 1065 CE, one of the participants declares, "My necklace and ornaments are of human bones; I dwell among the ashes of the dead and eat my food in human skulls.... We drink liquor out of the skulls of Brāhmans; our sacred fires are fed with the brains and lungs of men mixed up with their flesh, and human victims covered with the fresh blood gushing

from the dreadful wound in their throats, are the offerings by which we appease the terrible god [Mahā Bhairava]."[16] The skull used for wine and other libations offered to the gods is known as a *kāpala*. Through a long etymological excursus, this word eventually issues in the German *kopf* (head) and English *cup*.[17] In one of the few examinations of this practice, B. Laufer notes, "some of these skull-bowls are elaborately mounted and decorated, lined with brass or gilded copper and covered with a convex, oval lid that is finely chased and surmounted by a knob in the shape of a thunderbolt . . . , the symbol of Indra, which is in constant use in nearly all Lamaist ceremonies. The skull itself rests on a triangular stand, cut out with a design of flames, at each corner of which is a human head. These settings are frequently very costly, being in gold or silver, and studded with turquoise and coral."[18] Since the efficacy of the rituals depends on the quality of the skull, Lamas have developed an elaborate system of evaluation reminiscent of nineteenth-century phrenology. The shape, contour, and color of the skull reveal whether the person was religious, wise, and noble. For the karmic power of the skull to become effective, it must be prepared according to strict religious procedures. In some cases, the kāpala appeared to be so powerful that it became the object of worship. In addition to using skulls to make kāpala, Lamas fashioned tambourines for religious ceremonies from skullcaps, and used the thigh bones of criminals who died a violent death to make trumpets that can both solicit and frighten demons. Commenting on these practices, one Lama reports, "the people, at hearing of such trumpets, cannot fail to be mindful of death. For the same reason we avail ourselves of bones of the dead for rosary beads. Finally, in order to be still more imbued with this melancholy and sad remembrance, we drink from the cranium."[19] Once again the ambiguity of bones is clear: they are a *memento mori* that also holds the promise of spiritual renewal.

The figure of the skull also plays a pivotal role in the Christian drama of death

and rebirth. According to biblical accounts, Jesus was crucified on Golgotha, which means skull in Aramaic.

> They brought him to Golgotha, which means "Place of a skull." He was offered drugged wine, but he would not take it. Then they fastened him to the cross. They divided his clothes among them, casting lots to decide what each should have. (Mark 15:22, cf. Matthew 27:33, Luke 23:33 and John 19:17)

Though some commentators have argued that the crucifixion site was named Golgotha because of the skulls accumulated from previous executions, a more likely explanation is that the rock formations on the hill resemble a human skull. From the earliest days of Christianity, skulls and bones have been objects of meditation, veneration, and speculation. It is not only Shakespeare's Hamlet who finds lessons in a skull. In his formidable *Phenomenology of Spirit*, Hegel goes so far as to claim, "the skull-bone does have in general the significance of being the immediate actuality of Spirit." In Hegel's comprehensive vision, the entire natural and historical world is the embodiment or, in theological terms, the incarnation of spirit. The immaterial and the material are not separate and opposite but are alternative revelations of the same reality. "If now the brain and spinal cord together constitute that corporal *being-for-self* of Spirit, the skull and vertebral column form the other extreme to it, an extreme which is separated off, viz., the solid, inert Thing. When, however, anyone thinks of the proper location of Spirit's outer existence, it is not the back that comes to mind but only the head."[20] Here *the* philosopher who defines modernity echoes the ancient shamanistic belief in mystic power of bones.

Christian faith and practice are not only bound to bones by Golgotha. During the Roman Empire, Christians held worship services surrounded by bodies and bones. To escape persecutions, Christians commonly met around tombs and in

catacombs to honor the dead. Since the burial grounds provided seclusion from the vigilant eyes of the Roman authorities, these gatherings eventually became full-blown religious services. Though the situation of the Christians changed dramatically after the conversion of Constantine, the association of religious ceremonies with the place of the dead can still be discerned in major churches and cathedrals, which, beginning with the basilicas of Saint Peter in the Vatican and Saint Paul on the Via Ostia, were built over the graves of martyrs. In later centuries, this practice spread throughout Europe until basilicas and cathedrals eventually became necropolises where proximity to the altar was determined by religious prestige and social rank. The church is literally built on the bones of martyrs and believers.

During the Middle Ages, these bones were often on display. While most bones were remnants of anonymous believers and nonbelievers, some were purported to be the remains of martyrs. By this time, the custom of individual burial had, for most people, given way to internment in mass unmarked graves. As the urban population grew and burial space became a problem, it became customary to dig up the bones and display them in galleries and ossuaries called charnels or charnel houses. Rather than a permanent resting place, graves became pits where flesh could rot—the faster, the better. In the late Middle Ages, if the body had to be transported, it was boiled to separate flesh and bone. In his monumental work, *The Hour of Our Death*, Philippe Ariès reports, "the flesh was buried at the place of death, which provided an excuse for an initial tomb. The bones were saved for the most desirable burial place and the most impressive monuments, for the dry bones were regarded as the noblest part of the body, no doubt because they were the most durable." Elsewhere Ariès cites a Breton hymn that encourages the faithful to ponder the bones stacked in charnels.

> Let us to the charnel, Christians, let us see the bones
> Of our brothers....

Let us see the pitiful state that they have come to....
You see them broken, crumbled into dust...
Listen to their lessons, listen well....

"It was important to *see*," Ariès explains. "The charnels were exhibits. Originally, no doubt, they were no more than improvised storage areas where the exhumed bones were placed simply to get them out of the way, with no particular desire to display them. But later, after the fourteenth century, under the influence of a sensibility oriented toward the macabre, there was an interest in the spectacle for its own sake."[21]

In some cases, the spectacle became quite grand. The crypt of Santa Maria della Concezione in Rome, designed and built by Antonio Casoni (1626–30), contains the bones of four thousand Capuchin friars who died between 1528 and 1870. The bones are configured in extraordinary sculptural displays. The ceilings are decorated with vertebrae, lights hang from leg bones, and a clock made of vertebrae and foot bones tolls the passing of time. Thousands of skulls line the walls, making it impossible to escape their empty gaze. Equally impressive for its macabre art is the Sedlec ossuary, located in the graveyard of the Church of All Saints in what is now the Czech Republic. In the thirteenth century, an abbot brought back a jar of soil from Golgotha and scattered the contents in the church cemetery. During the following centuries, Sedlec became one of the most popular burial sites for religious leaders, noblemen, and dignitaries. By the sixteenth century, the bones had to be gathered and stored in the ossuary to make room for more corpses. In 1870, a local nobleman commissioned an artist named Franz Rindt to decorate the interior of the chapel with the bones of forty thousand skeletons that had accumulated. The results are spectacular. Rindt fashioned the bones into pillars, reliefs, an altar, fifteen-foot wide bells, and abstract patterns and designs. An imposing chandelier is supposed to contain every bone

in the human body. Other ossuaries scattered throughout Europe even display desiccated corpses presented as if they were works of sculpture. The lessons these bones teach is less about rebirth than about the brevity and vanity of life.

When bones are not anonymous, their power derives from the lives of the dead. The belief in the miraculous power of bones eventually led to their veneration as holy relics. The word *relic* derives from the Latin *reliquiae*, which originally meant any mortal remains. In the Catholic tradition, *relic* eventually came to designate the saint's body and objects that had direct contact with it during his or her lifetime. While clothing and items used in worship were important, the most prized relics were actual body parts like hair, skin, and bones. The worship of relics is not limited to Catholicism; indeed, relics associated with the Buddha, Mohammed, and Confucius are also enshrined and adored. In whatever tradition it occurs, belief in the effectiveness of relics involves what might be described as the metaphysics of presence in which physical proximity bestows benefits and provides protection. The martyr effectively inhabits the relic, which is capable of transmitting grace, virtue, and even life itself. As belief in the power of relics spread in eastern as well as western Christendom, demand for them grew and bones became big business. Their draw was not only spiritual but also political and even economic. From the time of Charlemagne, no church could be consecrated without a relic. Competition for relics and the prestige they brought frequently resulted in bodies being moved and even stolen. When the relocation of the corpse was legitimate, it took place according to a ritual known as translation. By the fifth century, the demand for bones and body parts was so great that the practice of exhuming, dismembering, and distributing the bodies of saints became widely accepted. Amputated fingers, hands, feet, heads, and, of course, bones circulated throughout Europe. The more important the saint, the greater the power the remains bestowed. With increase in demand, supply became a problem and a profitable market in relics emerged. In the ninth century,

a group of enterprising entrepreneurs formed a corporation that specialized in the discovery, sale, and transport of relics throughout Europe. Neither ambitious churchmen nor credulous believers and pilgrims seemed to care that many of these relics had to be fake.

Through the centuries and across cultures, what makes bones so powerful is that *they last*. When all else is gone, bones remain and in their remains we see traces of those who once lived. To our society obsessed with denying death by hiding it from sight and mind, the fascination with bones might seem a morbid vestige of a primitive mentality from another era. Practices once deemed holy now appear grotesque. But things are never so simple; bones continue to haunt us. Paradoxically, we are always drawn to that which we struggle to avoid because the repressed never simply disappears but merely slips underground where it continues to preoccupy those who claim to deny it. There is no escape from bones; their shadows prefigure our future.

FIGURING BONES

Is the veneration of bones a thing of the past? Do bones still have stories to tell and lessons to teach? Can we still read their lines, decode their cracks, decipher their curves? If bones are mystic, how can they be figured today? What if bones were works of art?

One of the most important ways in which the sacred is disclosed today is through art. Modernism and postmodernism recover the unity of art and religion that had long been lost. While commercialism and market forces have undeniably increased in the last hundred years, many of the most important twentieth-century artists freely admit a spiritual dimension in their work. Even those who do not do so frequently pursue religious issues without realizing or admitting it. The spirituality that inspires artists is in many cases ancient or even

primitive. The reconciliation of art and religion often is found where it seems most unlikely. Nietzsche, who is, of course, infamous for the declaration of the death of God, actually insists that God is "the supreme artist, amoral, recklessly creating and destroying, realizing himself indifferently in whatever he does or undoes, ridding himself by his acts of the embarrassment of his riches and the strain of his internal contradictions."[22] Decades later, the poet Wallace Stevens, who was one of Nietzsche's most devoted followers, refashioned his insight in lines designed to mock the sterile theses of unimaginative logicians:

> Proposita 1: God and the imagination are one. 2. The thing imagined is the
> imaginer.
> The second equals the thing imagined and the imaginer are one. Hence, I
> suppose, the imaginer is God.[23]

In this vision, the Creator God dies and is reborn as creative activity. Creativity occurs wherever the unexpected emerges and, thus, can be either human or inhuman. Indeed, human creativity is always surrounded by and immersed in a creativity greater than itself. Creativity is at work not only in the human imagination but also throughout the entire cosmos—from the highest to the lowest, from the animate to the inanimate. For those with eyes to see, there is a certain mysticism of matter. Meister Eckhart, one of the greatest mystics in the Christian tradition, once said, "Stone is God but doesn't know it." So too are bones.

Nature and culture meet in the art of bones. Like intricate designs etched on canyon walls by centuries of wind, rain, ice, and sand, bones reveal a beauty far vaster than any conceived by human invention. This is a world where straight lines are deviant and right angles are wrong. The curves of bones are as elegant as a Brancusi arc, their twists as fine as a Picasso line, their spirals as inviting as a Gehry building. These figures and forms, however, were designed without a designer, sculpted without a sculptor, plotted without an architect. Bones are works of art without an artist.

To suggest that bones are art is to stretch the notion of art beyond its traditional limits, to open the way for reconceiving the work of art. Rather than the image, concept, or object produced, the work of art can be understood as the creative activity of producing. In this light, art becomes a complex, autopoietic process of emergence. In producing works that shape our world, art eternally creates itself. The roots of this notion can be traced to ancient Greece where art was indeed understood as *poiesis* (a making). *Poiesis* is not limited to poetry in the traditional sense but involves a much more inclusive creativity. Heidegger underscores this point when writing about Hölderlin's poetry.

> For the "poetic," when it is taken as poetry, is supposed to belong to the realm of fantasy. Poetic dwelling flies fantastically above reality. The poet counters this misgiving by saying expressly that poetic dwelling is a dwelling "on this earth." Hölderlin thus not only protects the "poetic" from a likely misinterpretation, but by adding the words "on this earth" expressly points to the nature of poetry. Poetry does not fly above and surmount the earth in order to escape it and hover over it. Poetry is what first brings man onto the earth, making him belong to it, and thus brings him into dwelling.

> Full of merit, yet poetically, man
> Dwells on this earth.[24]

To dwell poetically is to live creatively. Contrary to the tenets of traditional Christian theology, creation is never ex nihilo but is always a recreation that transfigures the tissue of the given. Nature is *poiesis* without an artist; culture is *poiesis* fashioned through human activity. Thus, "every poem is a poem within a poem" and every work of art is a work within a work.[25] If the world is a work of art, bones are poems and their images are poems within poems.

The work of art, I am insisting, is not merely a human activity but is also a natural process. The foundational oppositions of western religion, philosophy, and

art—culture/nature, mind/body, subject/object, self/world—are illusory for, as Nietzsche once averred, "everything is entwined, enmeshed, enamoured."[26] To understand the world and our place within it, we must think in terms of complex webs that connect and interrelate rather than simple grids that separate and oppose. Whatever exists must come into being through the process of creative emergence whose structure and operational logic are the same across all media. Inasmuch as the world is a work of art, mind sees itself in nature and nature becomes aware of itself in mind. In human activity, creative emergence occurs through the *imagination*, understood not merely as the capacity to form mental images or concepts but as, in Coleridge's fine term, the *esemplastic power* of the mind. Like a primal demiurge, the imagination shapes, forms, and figures.[27]

All of this and more—much more—can be apprehended in the figures of bones. Never merely remnants of death, bones are traces of the creative process that figures all life. Their remarkable forms disclose patterns that can be discerned elsewhere. Each bone is a node in webs of relations that seem inexhaustible. To trace their curves and folds, to read their lines and faults is to discover new landscapes, moonscapes, desertscapes: mountains rising from lakes, hills covered in autumnal splendor, lunar knolls and valleys, desert dunes gracefully drifted, meandering streams and rivers. Though forms are not fixed, they recur through a process of iteration that establishes similarities without erasing differences. For all their endurance, bones are figures of Stevens's "evanescent symmetries" that we can glimpse but never fully grasp.

> Hi! The creator too is blind,
> Struggling toward his harmonious whole,
> Rejecting intermediate parts,
> Horrors and falsities and wrongs;
> Incapable master of all force,

Too vague idealist, overwhelmed
By an afflatus that persists.
For this, then, we endure brief lives,
The evanescent symmetries
From that meticulous potter's thumb.[28]

In bones we see what is most intimate exposed to the elements that wear away. As bones are refigured to create new forms, they gradually absorb the world that erodes them. Their colors and shapes reflect the earth from which we come and to which we return. To dwell *on*—to dwell *in* this earth is to accept that there is no elsewhere. Bones are undeniably a form of ridicule of our brief lives. And yet, if we learn to appreciate their inhuman beauty, they might teach us that we are entwined and enmeshed in something infinitely larger than ourselves. When this happens, bones again become mystic by revealing disillusionment to be the final illusion.

Photography, I hope to show, can help teach this lesson. Photographic images refigure figures to create what is neither completely original nor merely reproduced. Like mind and eye, the camera's sensor is not a blank slate awaiting exposure. Looking at bones through the camera, we see both nature and ourselves emerging and fading away. The lens seduces the bones to reveal secrets they usually withhold. Light, focus, and aperture reconfigure shapes to create forms never before figured. Not all these images of bones resemble nature; some are almost human—an outstretched hand, a clenched fist, an extended leg, a curled foot, even faces, some sad others happy, some gay others brooding, some welcoming others menacing, some sane others mad. Many other images are fascinating for their incomprehensibility, attractive precisely because we *cannot* say what they are. By suggesting something we have never seen and implying something we have never thought, figures take us somewhere we have never been. In the opaque,

obscure, oblique images of bones the unfigurable that keeps all figures open and renders the work of art endless approaches without ever arriving.

The desert is less a place than a state of mind. The following pages are the desert in which I invite you to err. If you do not rush, perhaps these ephemeral rubbings of reality will whisper in ways that allow you to see life anew. To find beauty in the most unexpected place is to discover that the sacred is not elsewhere but is always in our midst.

Take, read.
This is my body offered to you.

THE DESERT IS THE SPACE *of* **ERRING**

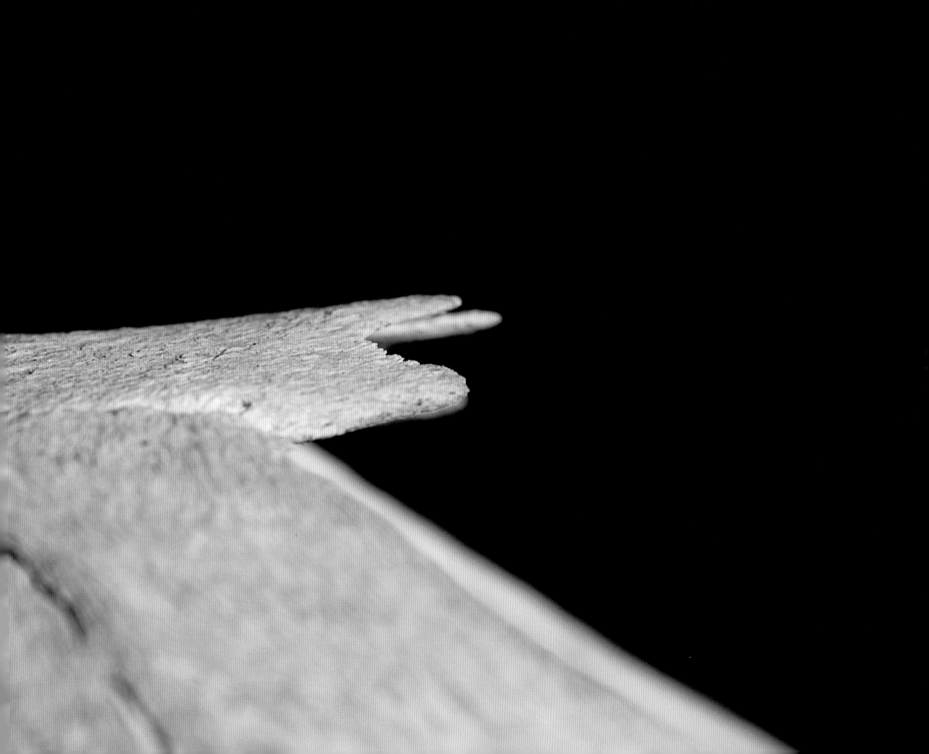

DESERT BONES *teach us what to ignore*

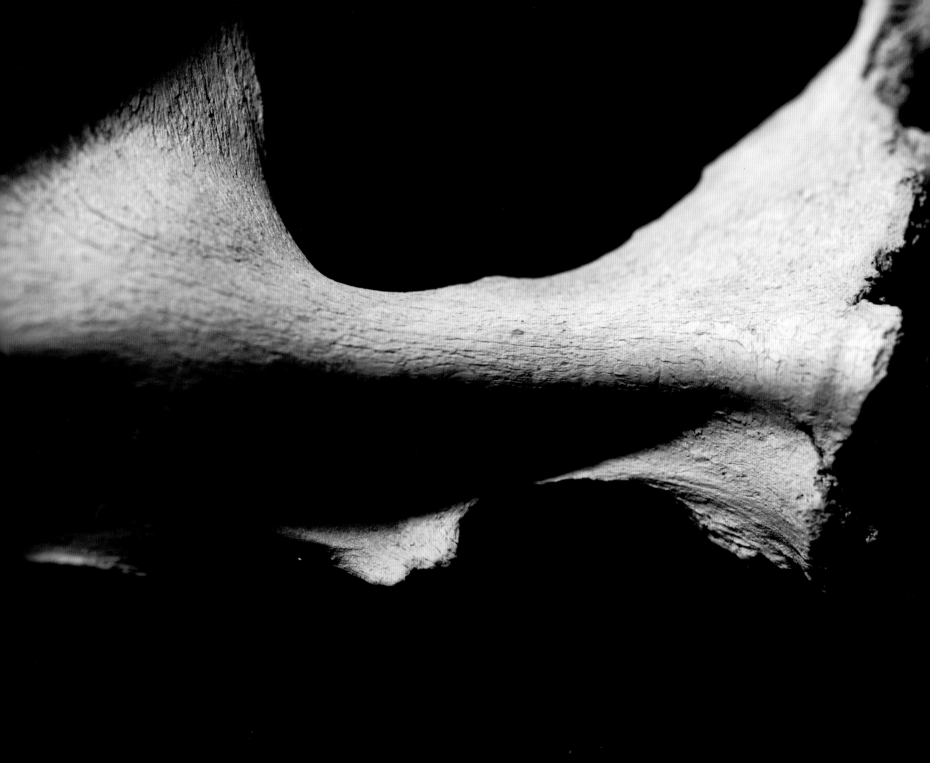

BONES DRAW US *elsewhere*

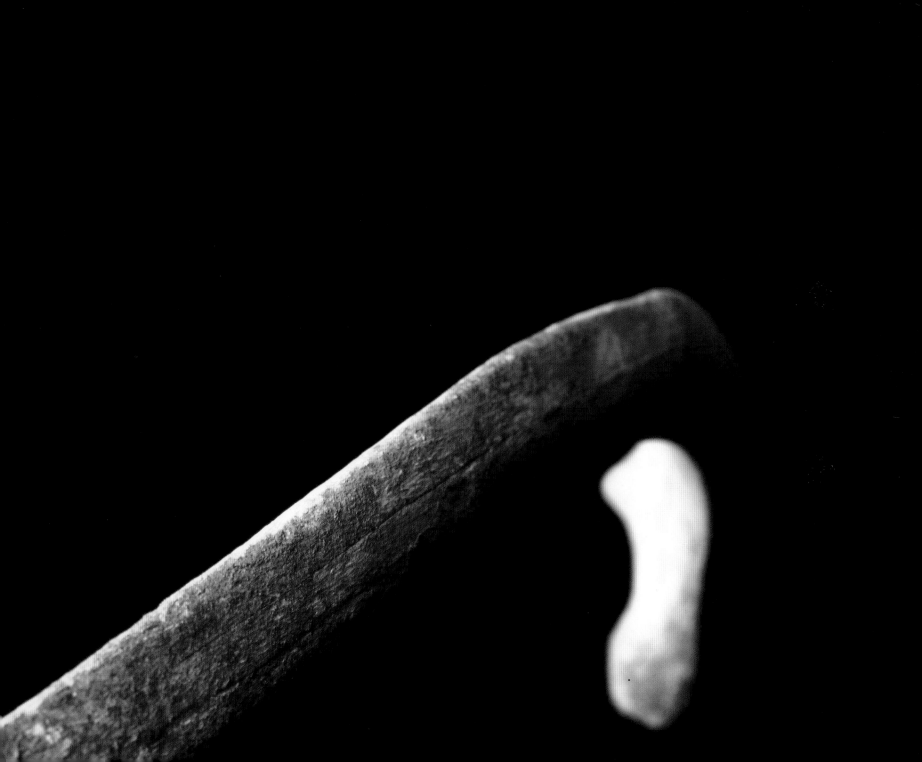

WE HAVE FORGOTTEN *the question*

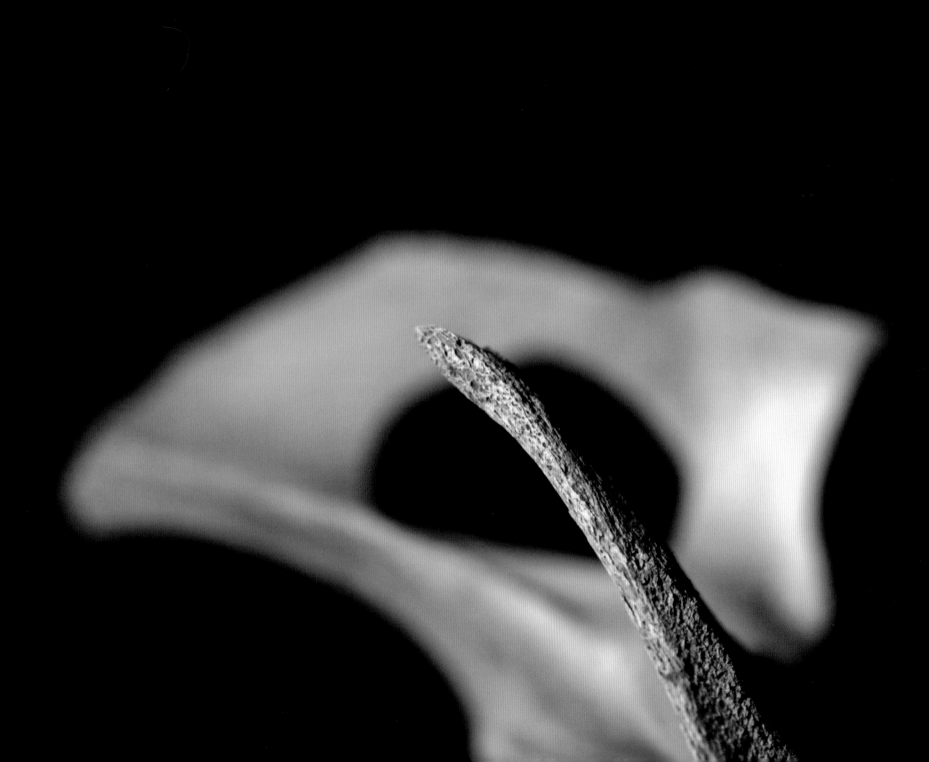

KNOWING *is not knowing*

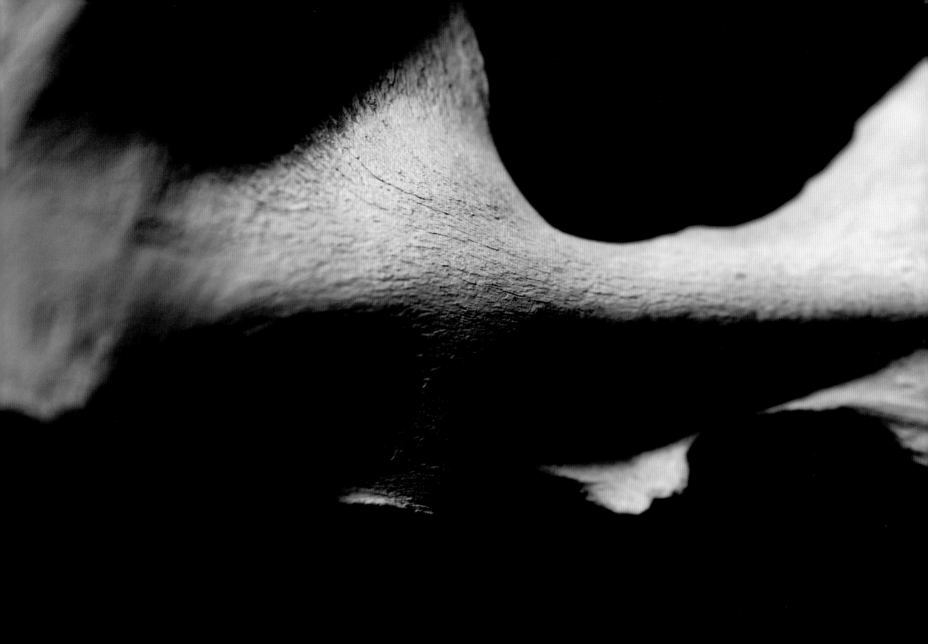

patience awaits the approach that **WITHDRAWS**

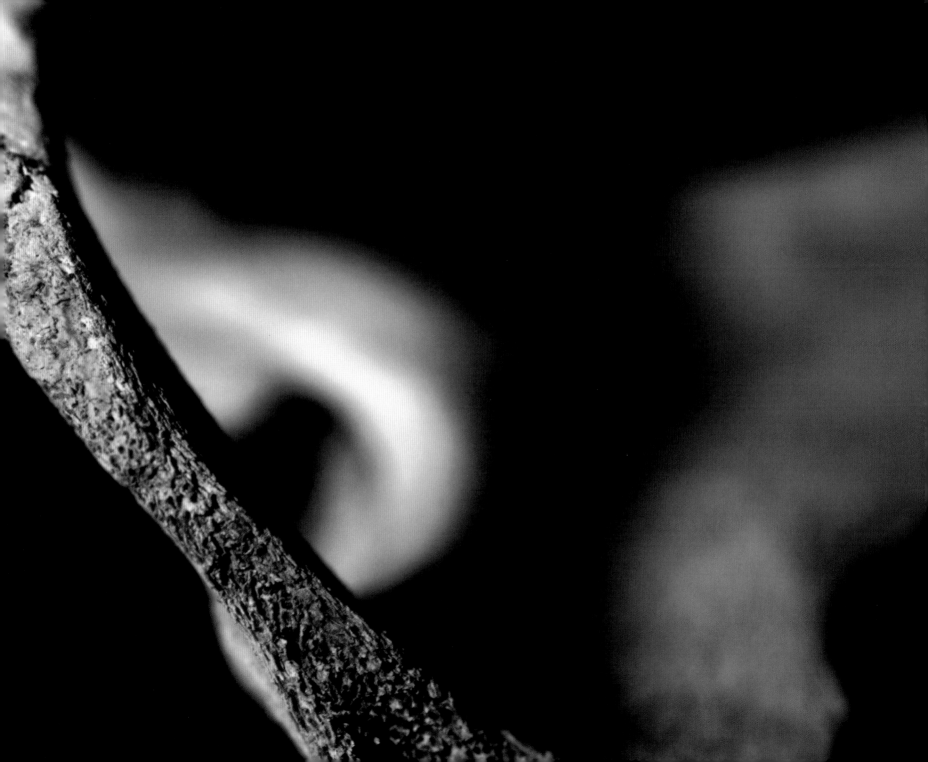

IMAGES REVEAL *by hiding*

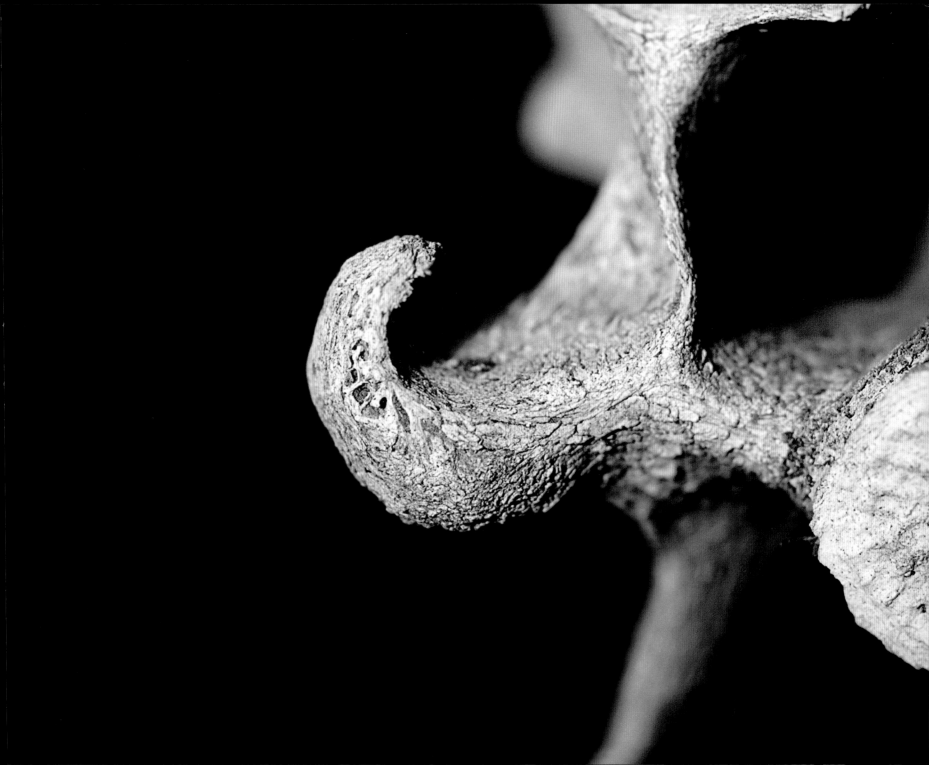

BEAUTY *disarms*

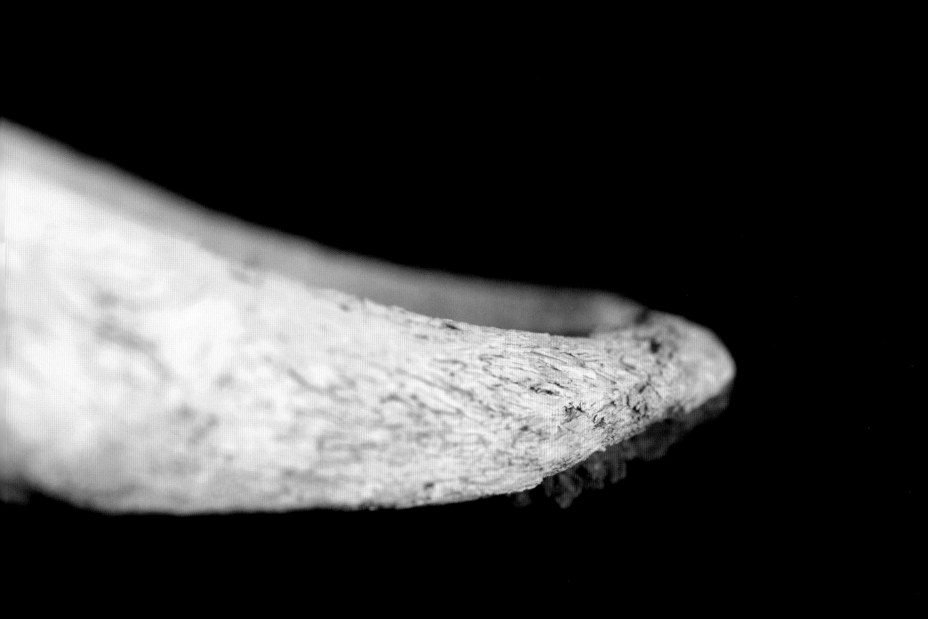

beauty is **INHUMAN**

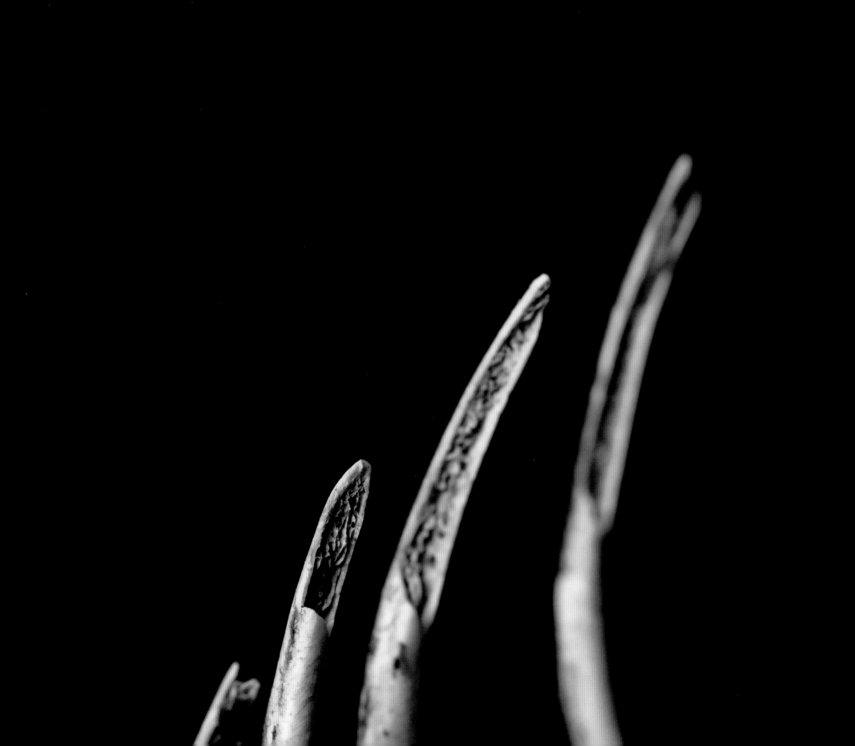

SILENCE SPEAKS *in* BONES

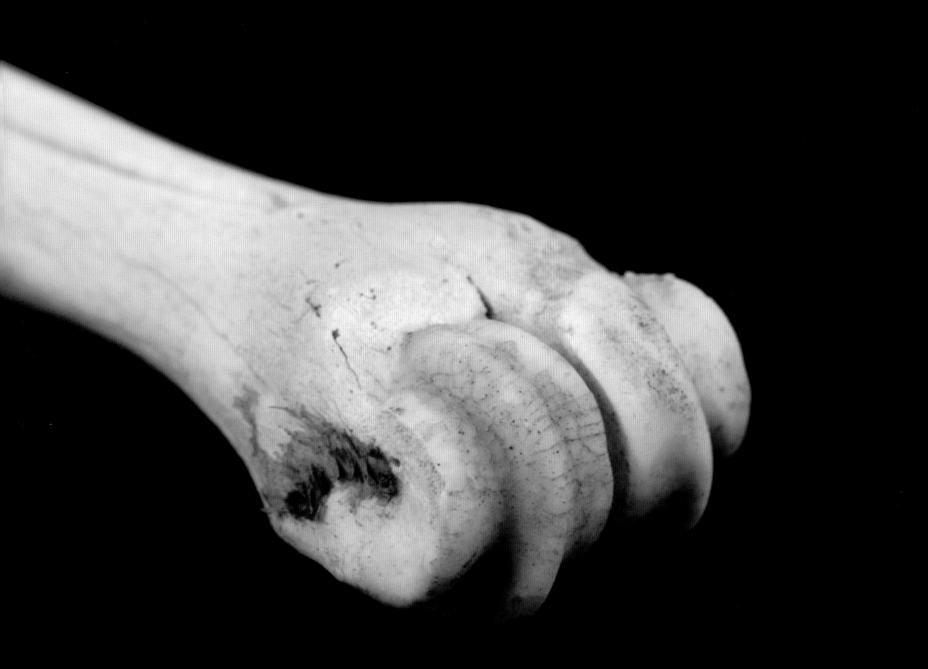

nothing is **HIDING**

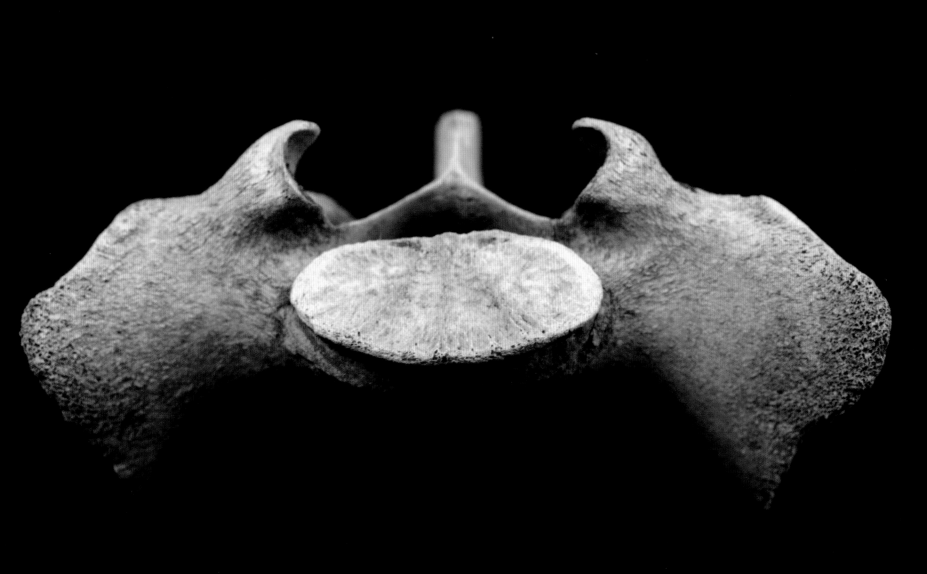

TO EXPOSE NOTHING IS TO REVEAL *everything*

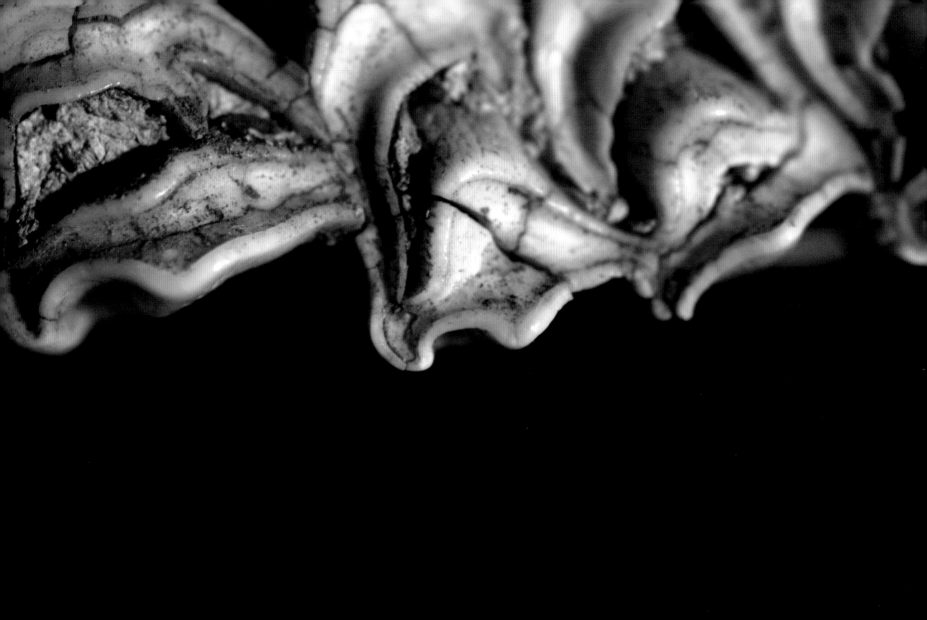

EARTH AND SKY *meet in bone*

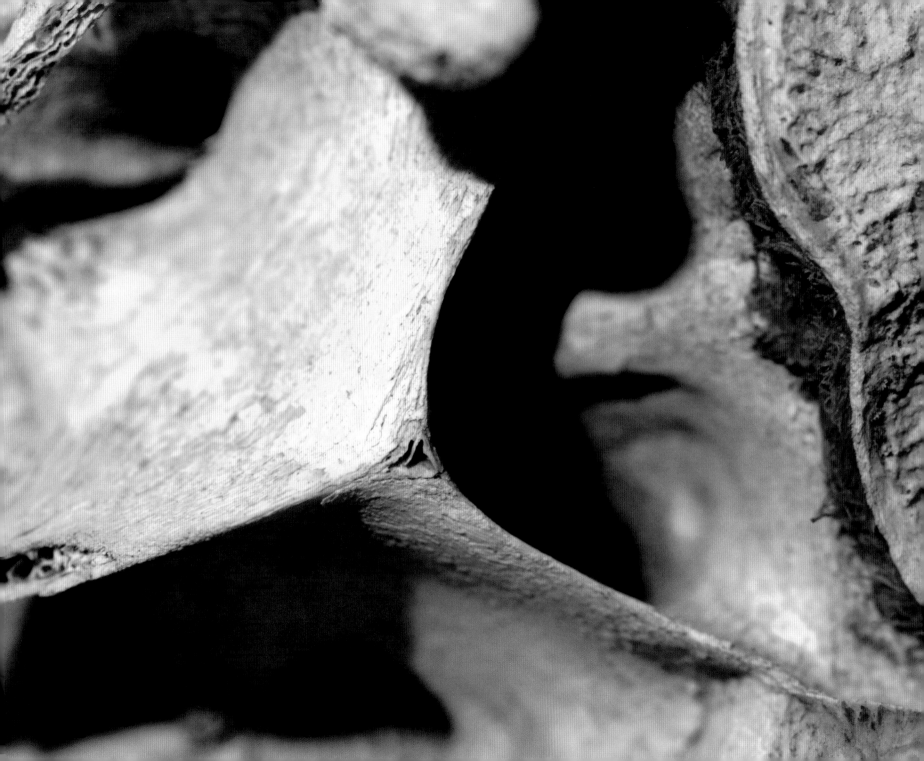

BETWEEN THE IMAGELESS AND THE IMAGED *is the space of desire*

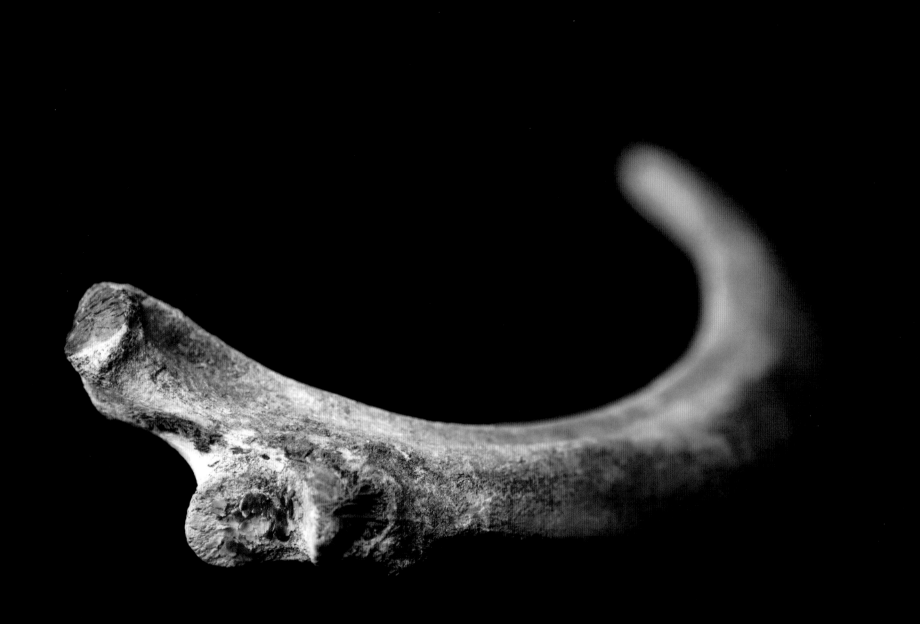

bones are **EROTIC**

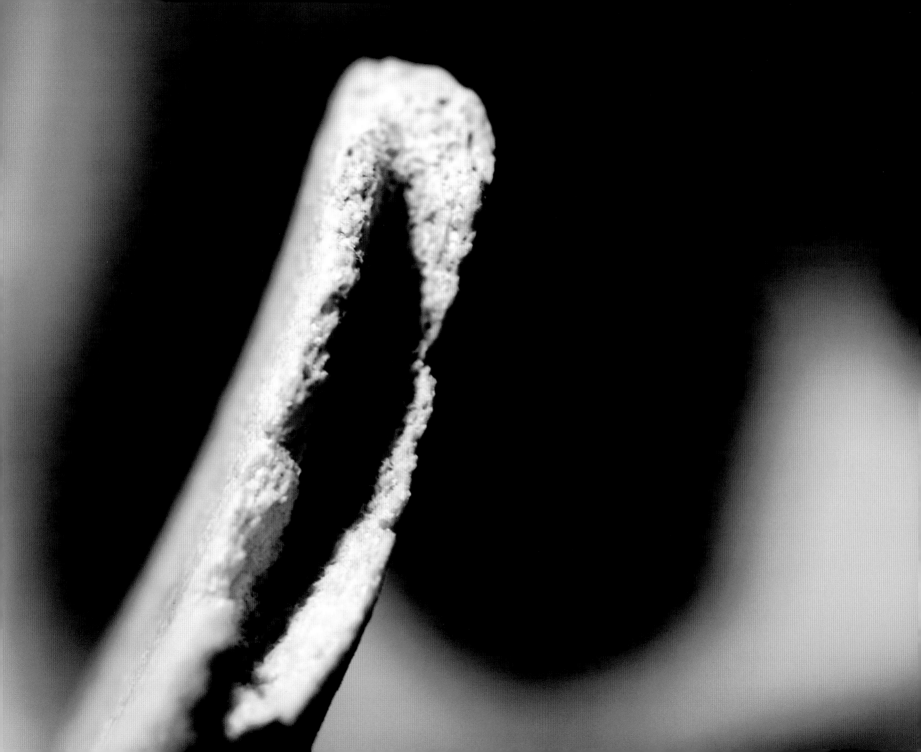

SATISFACTION *is death*

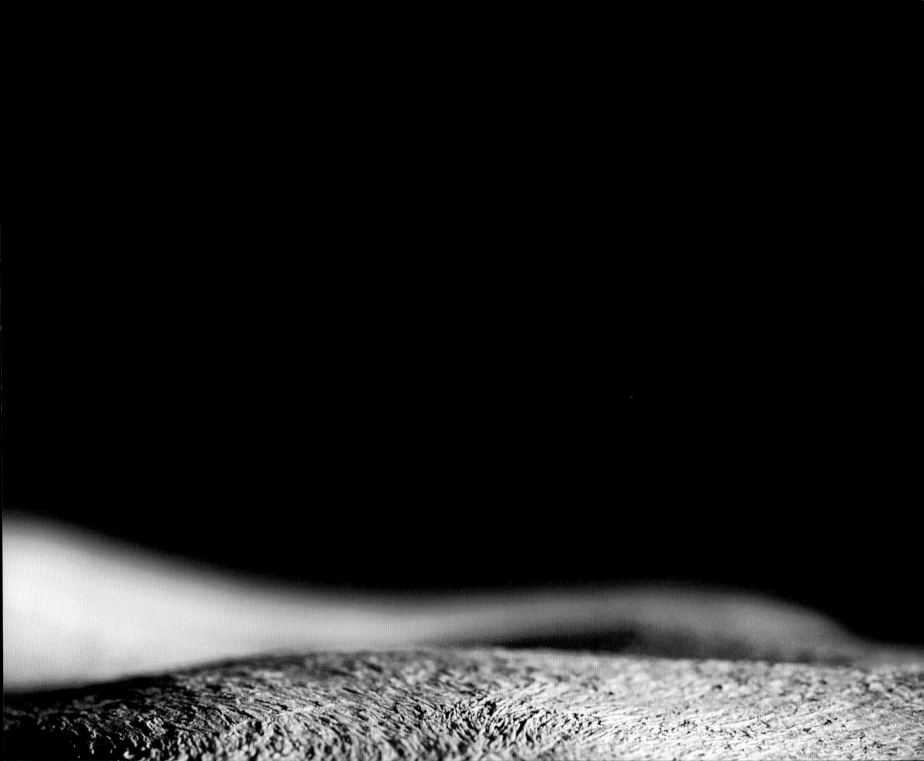

WHAT WOULD IT MEAN TO BE SATISFIED WITH NOTHING?

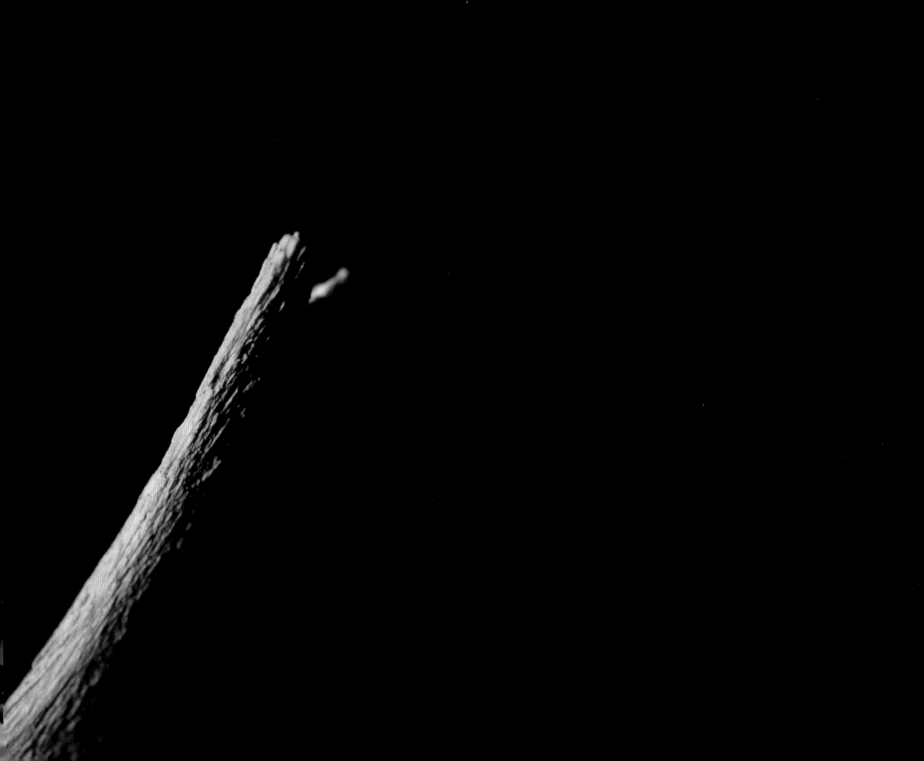

WITHOUT SURPRISE *no* BLISS

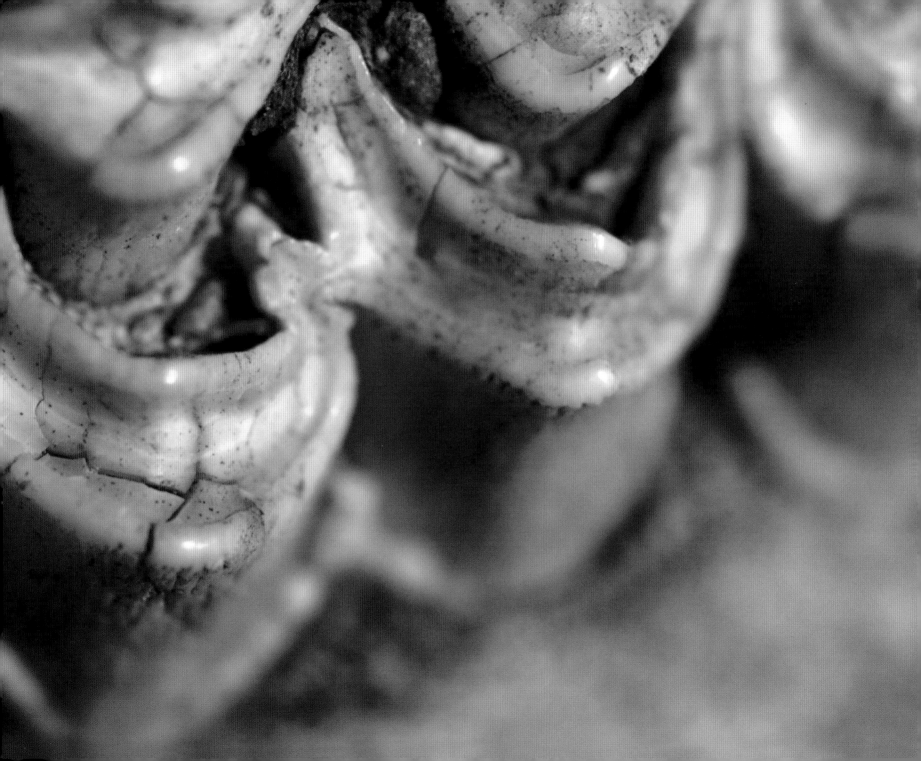

OBSCURITY *clarifies*

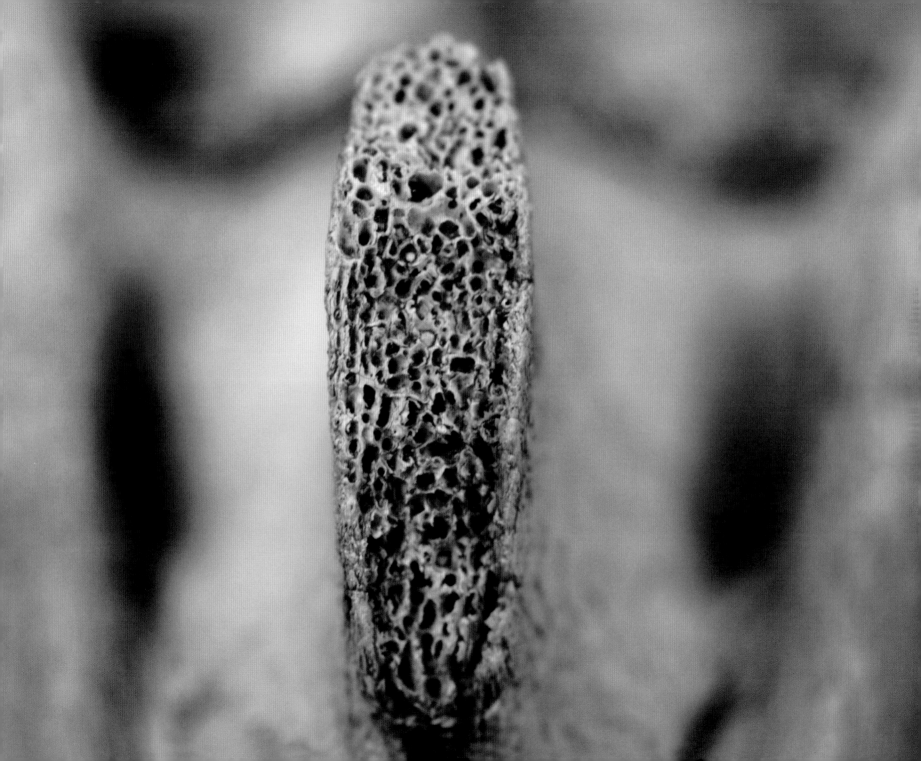

real and unreal are neither **DIFFERENT NOR THE SAME**

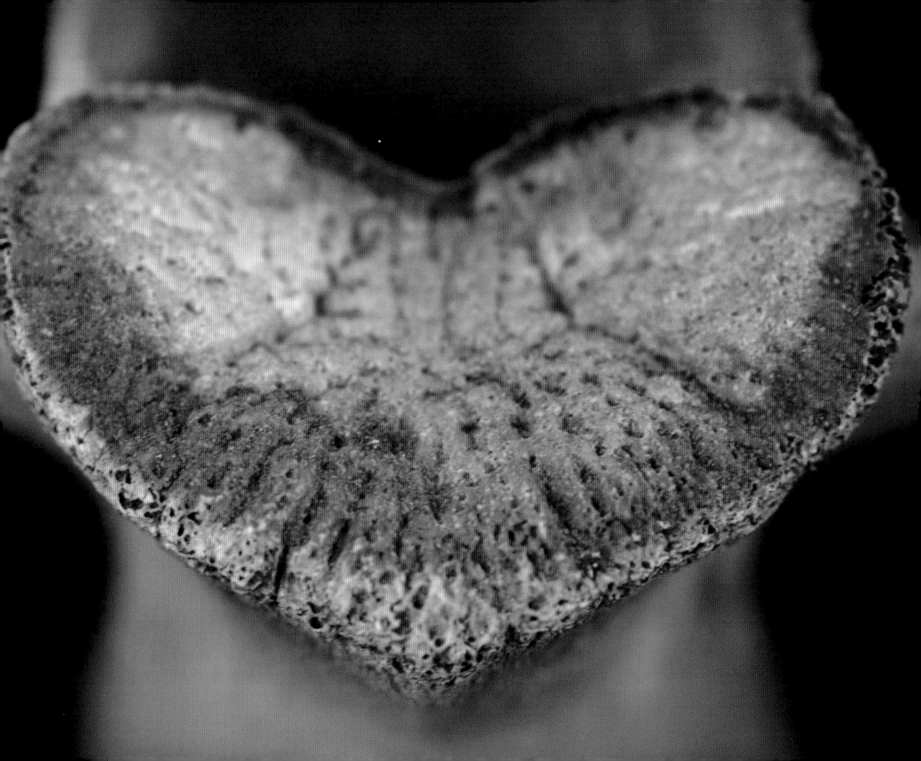

SINCE THE REAL IS ELUSIVE, *thought must be allusive*

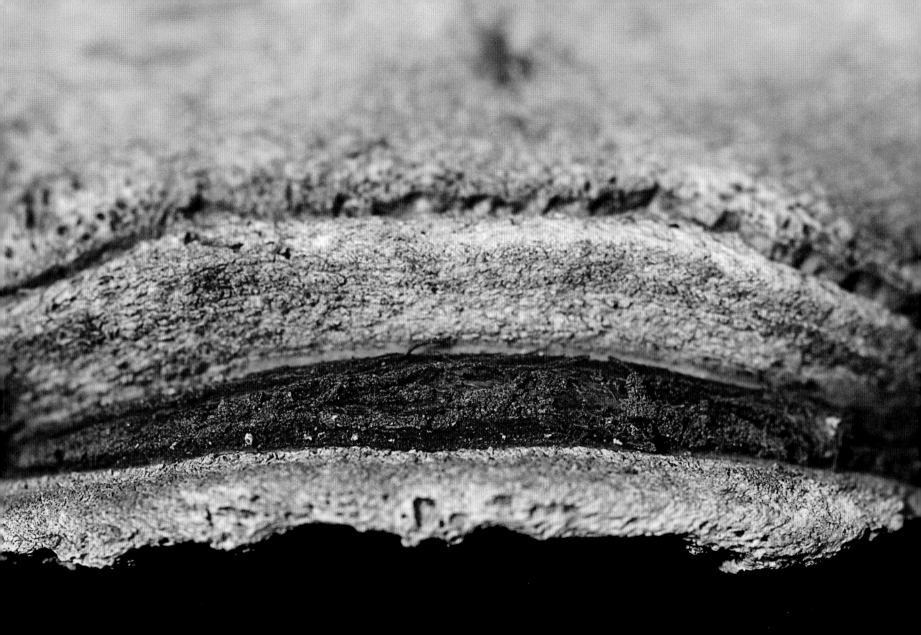

what is not present is not necessarily **ABSENT**

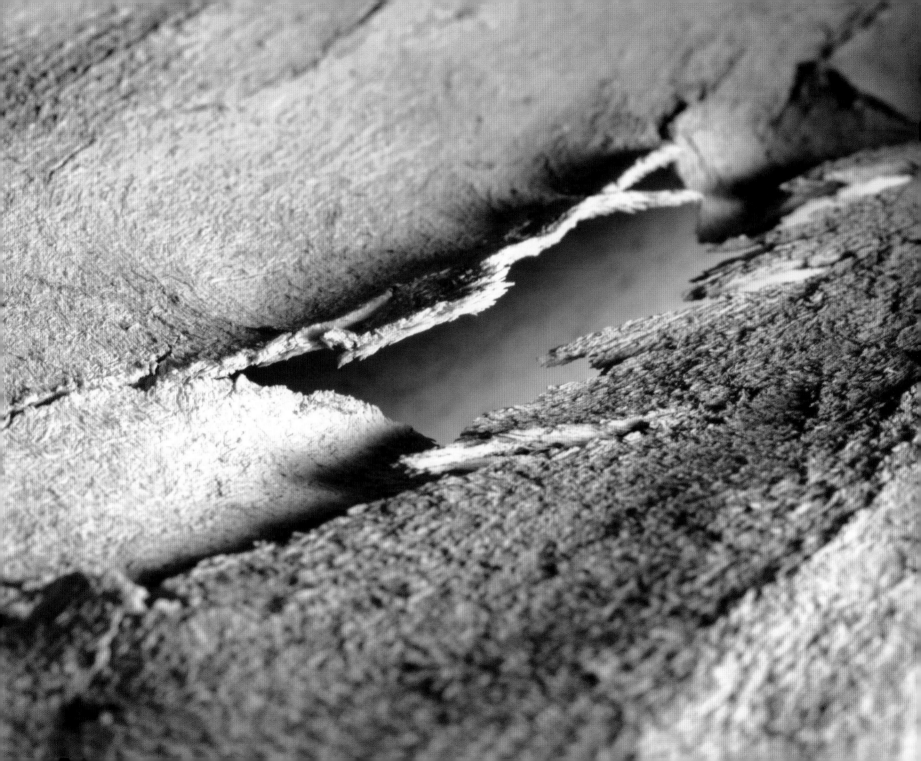

ELSEWHERE *is not far*

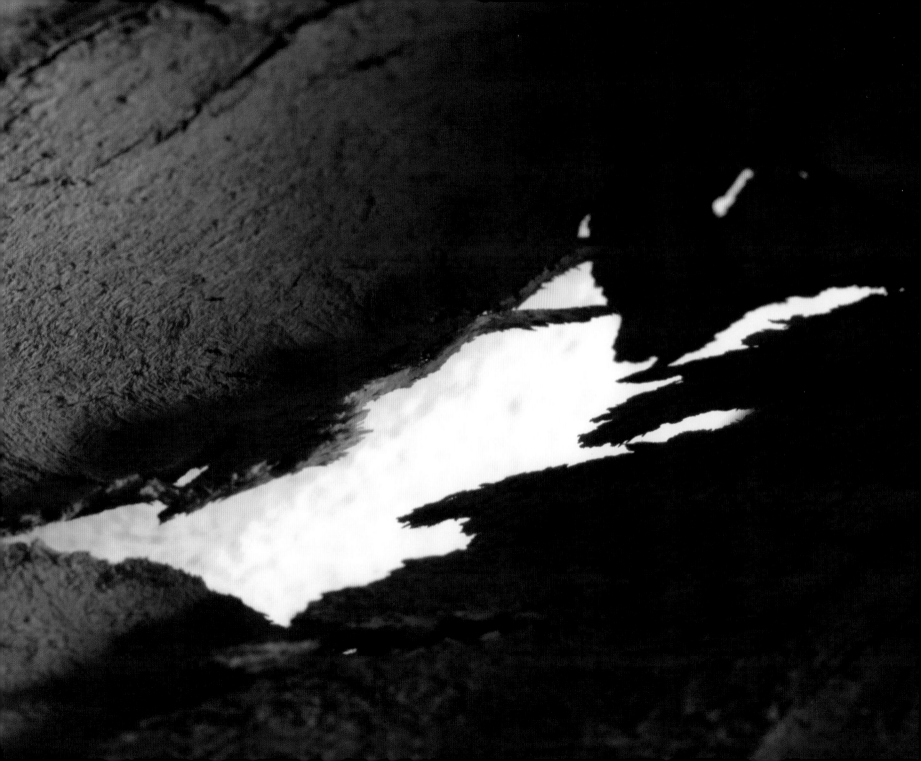

FACE *the strange*

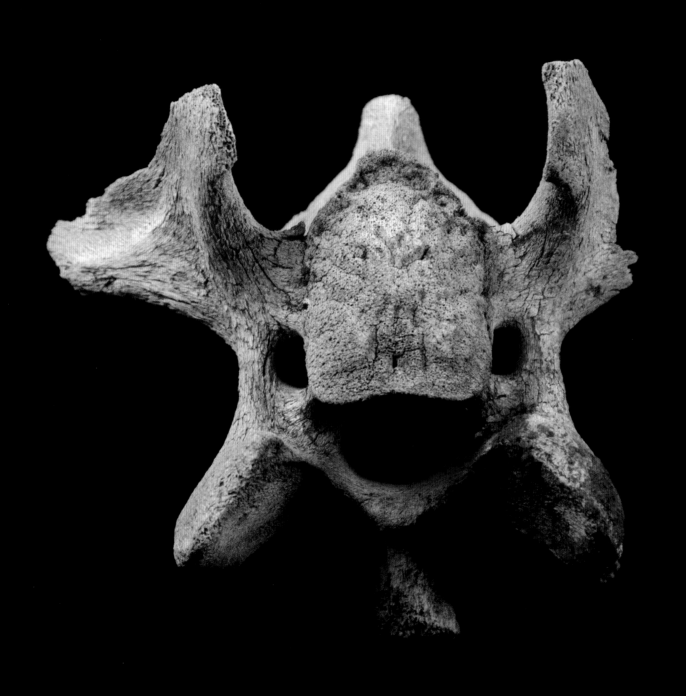

what is most intimate is **INVISIBLE**

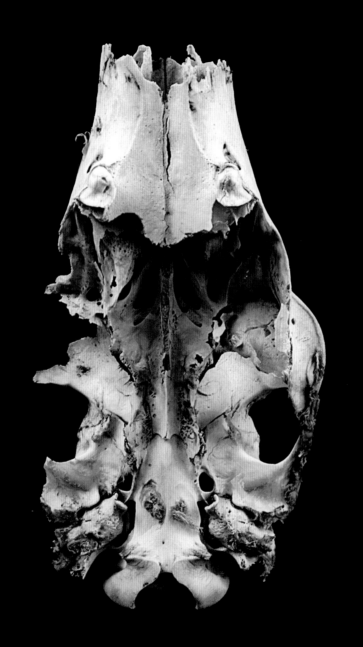

what is most personal is **ANONYMOUS**

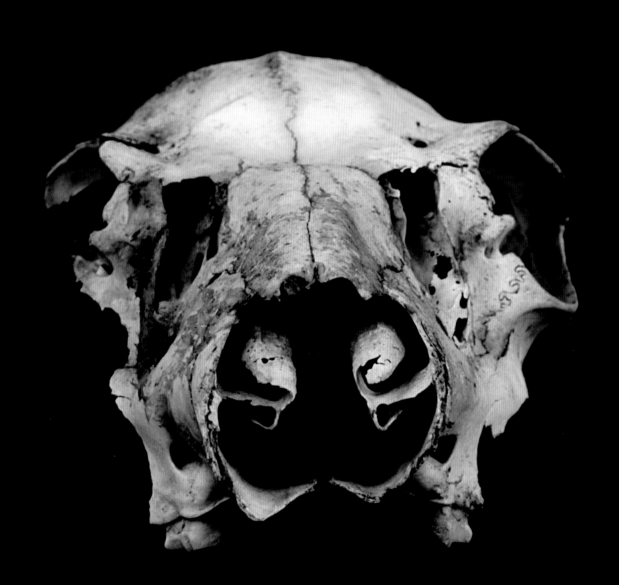

bones **RIDICULE**

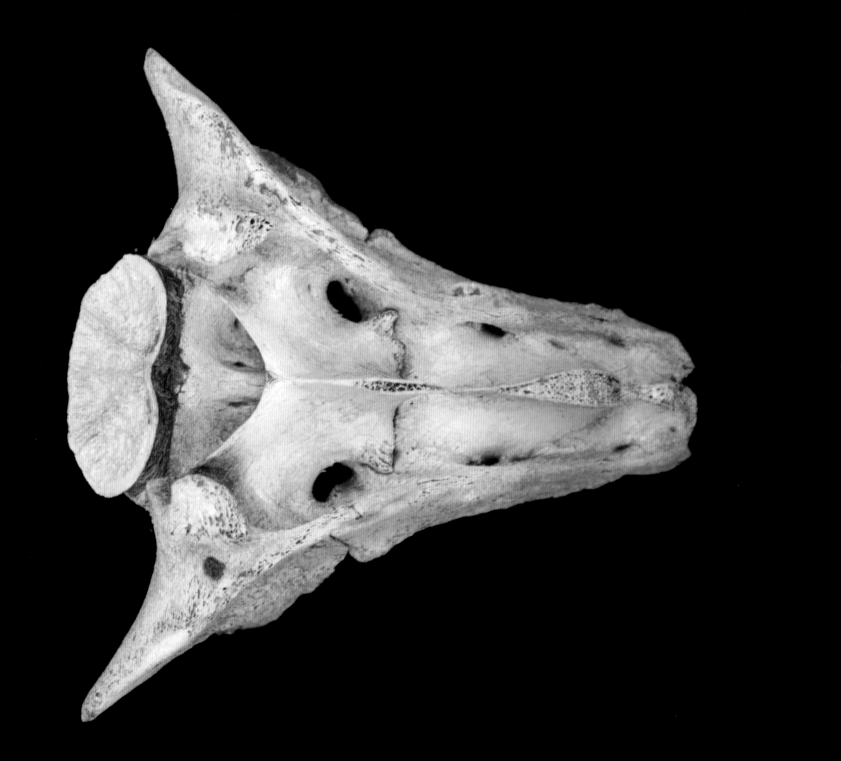

figures **DISFIGURE**

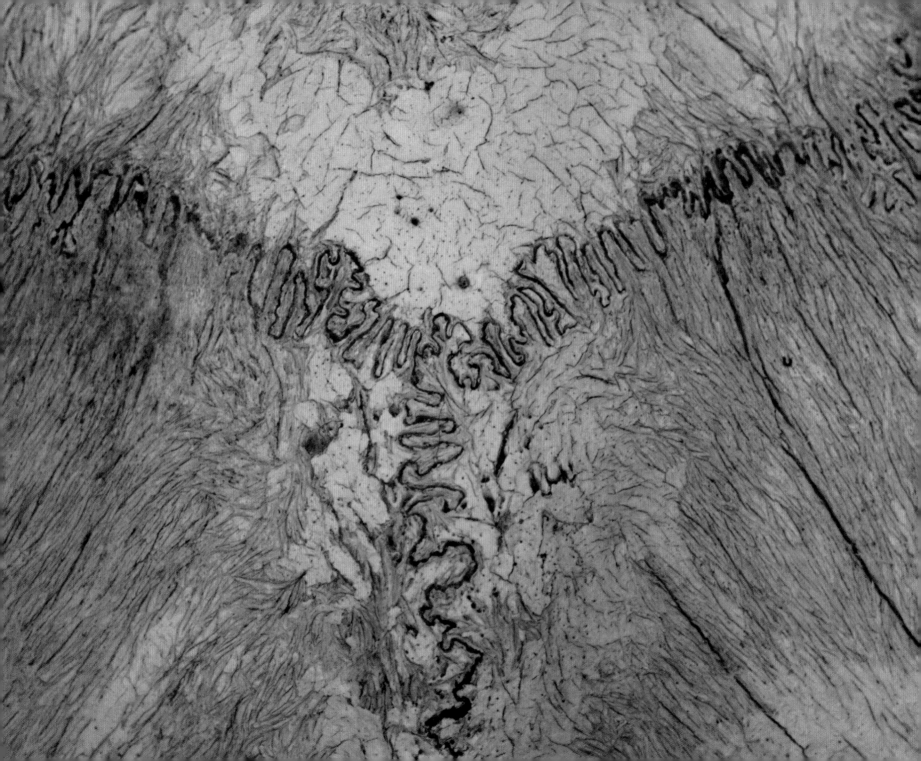

NO *pleasure without horror*

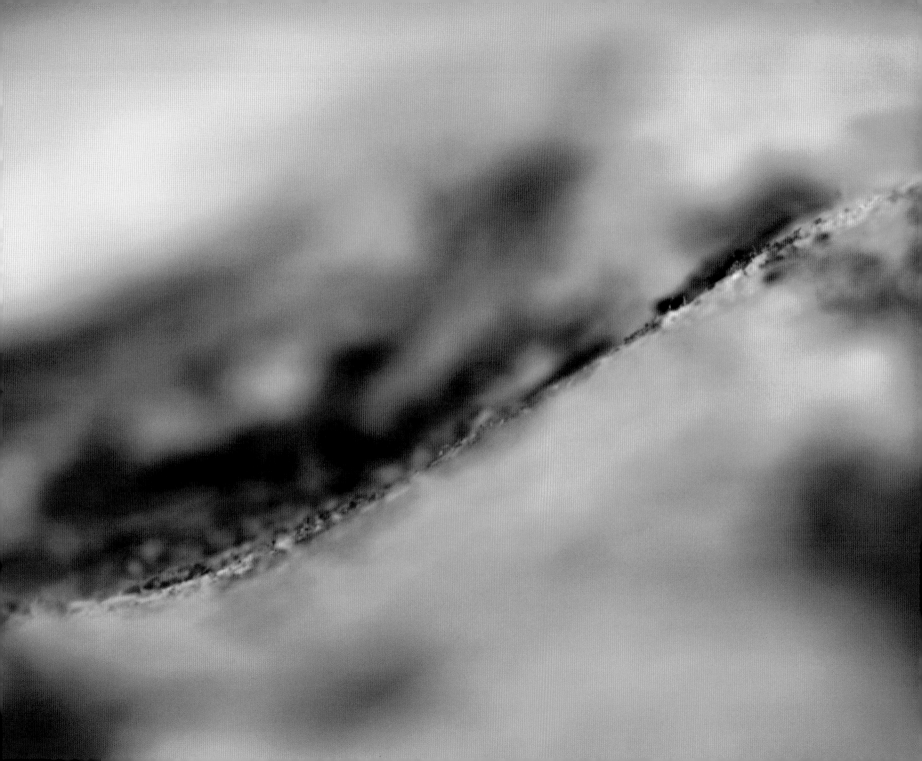

TO REMEMBER OBLIVION IS TO GLIMPSE *the* FUTURE

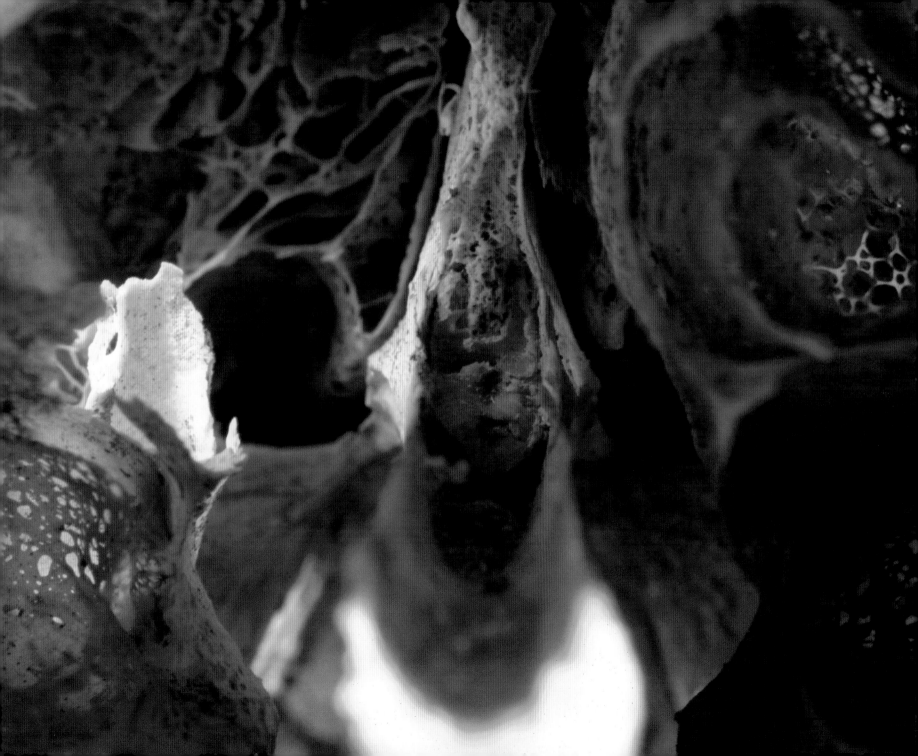

death **IS THE NECESSARY CONDITION OF** *life*

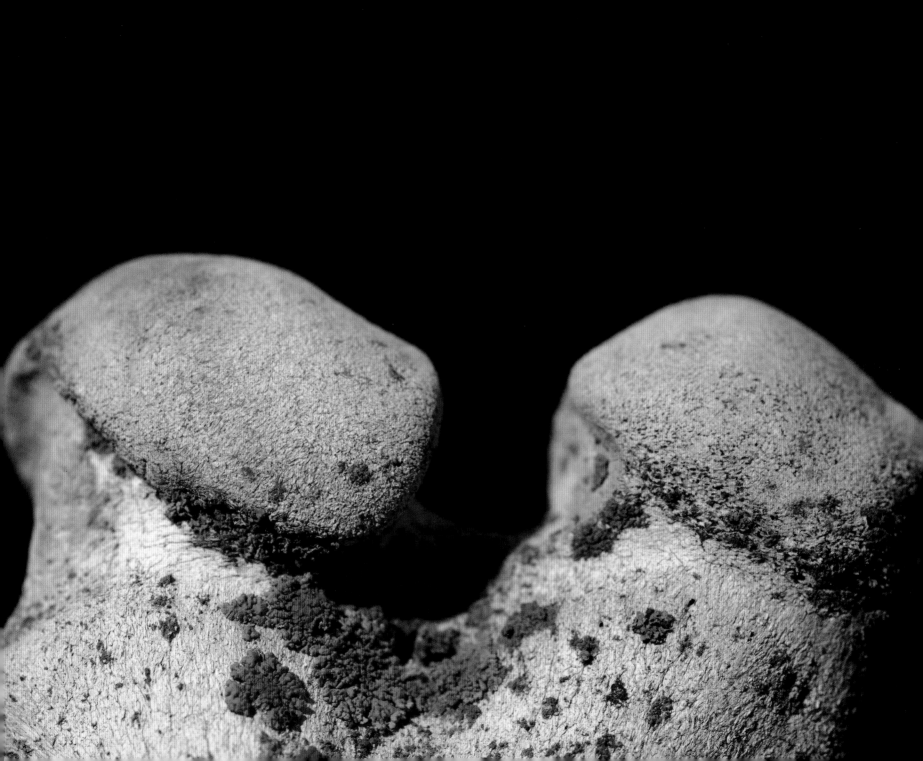

DEATH IS THE *end of dying*

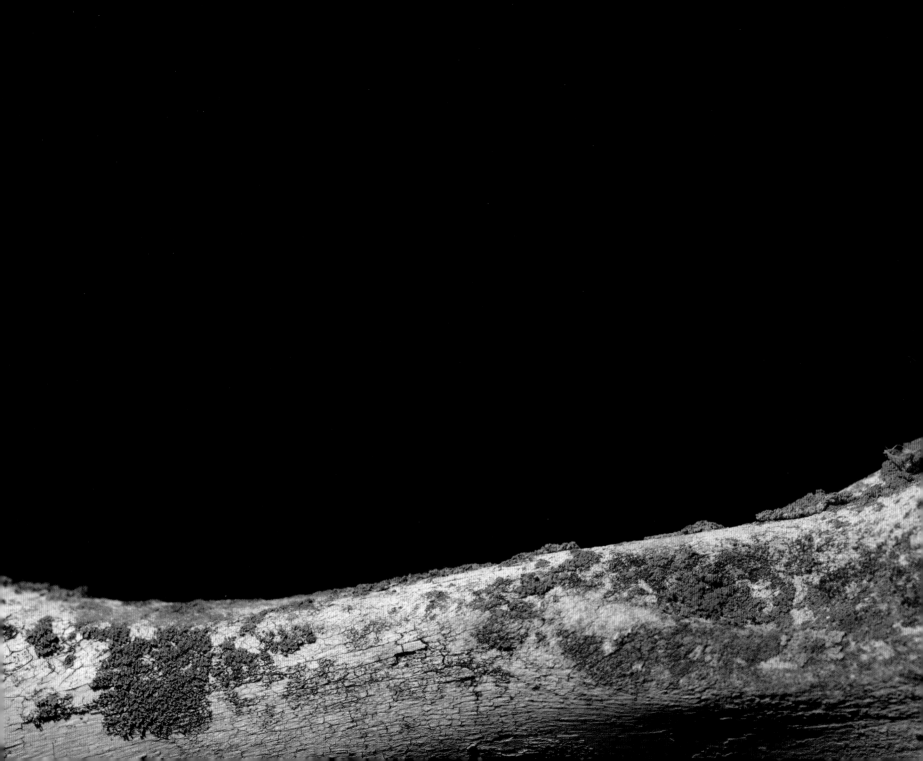

ABSOLUTE TRANSCENDENCE IS *relative* IMMANENCE

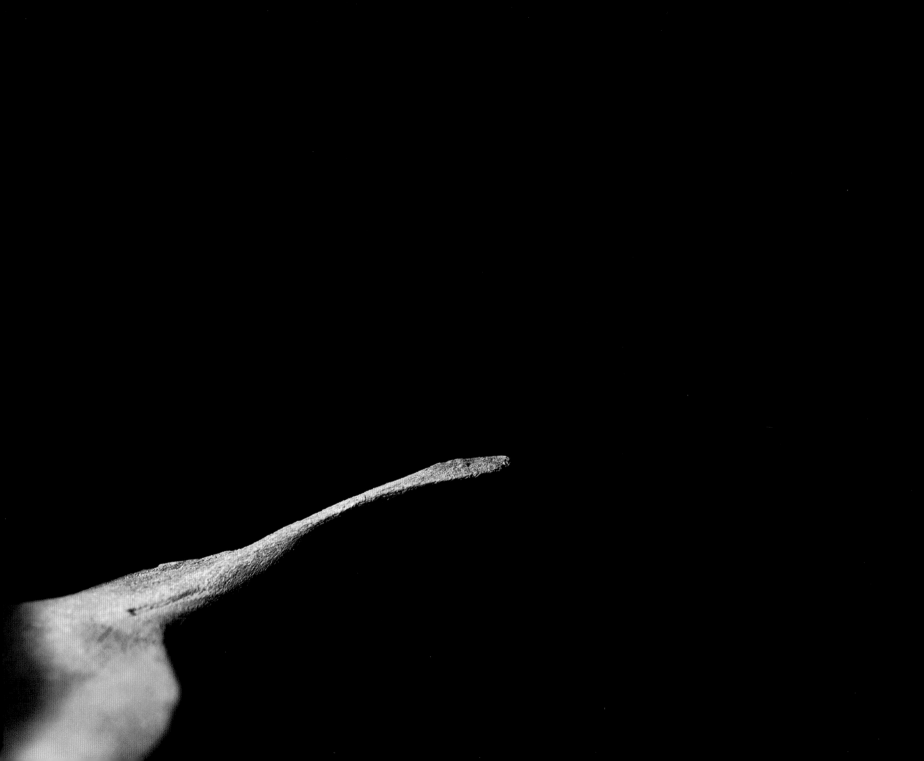

BONE IS GOD *but doesn't know it*

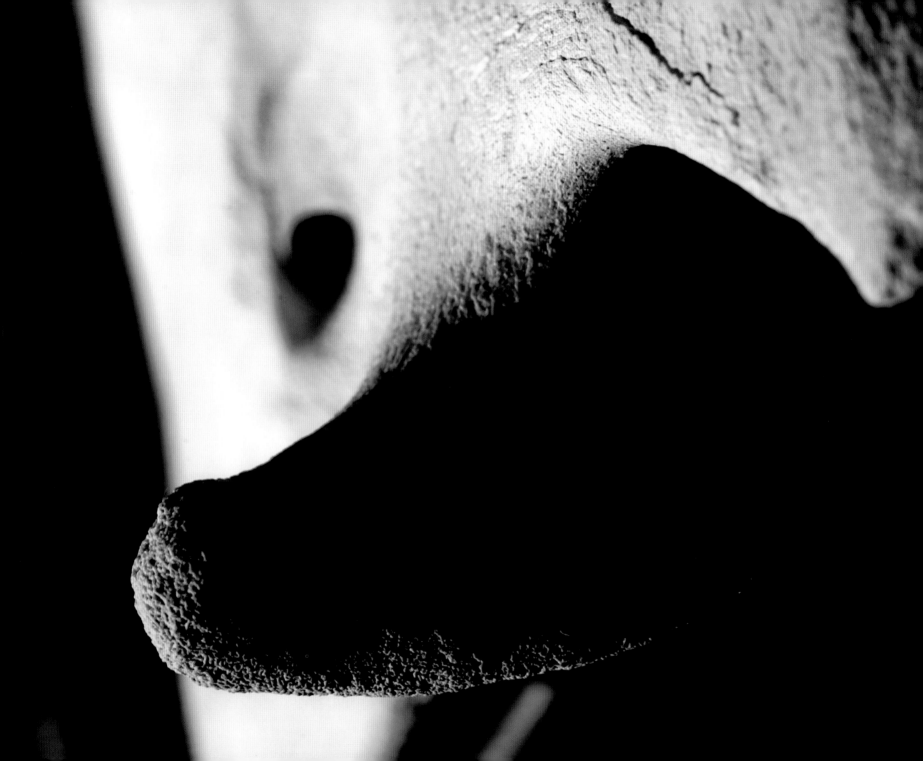

WHAT WOULD IT MEAN *to be through with not enough?*

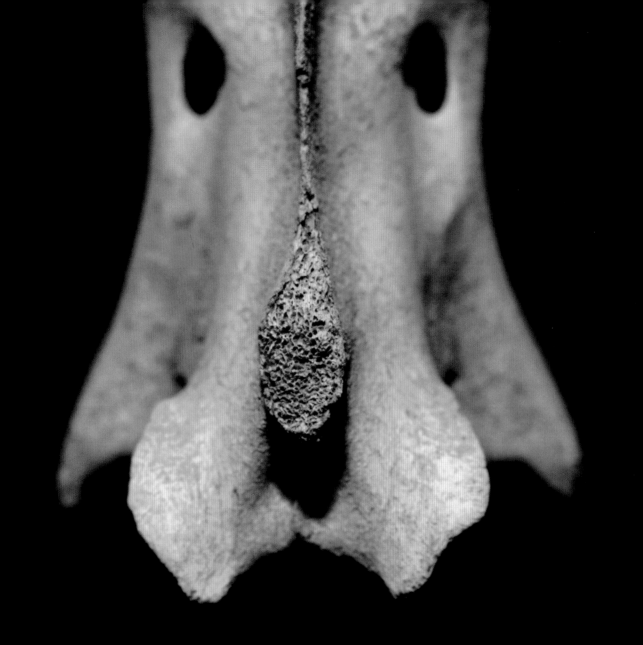

live **WITHOUT** *why*

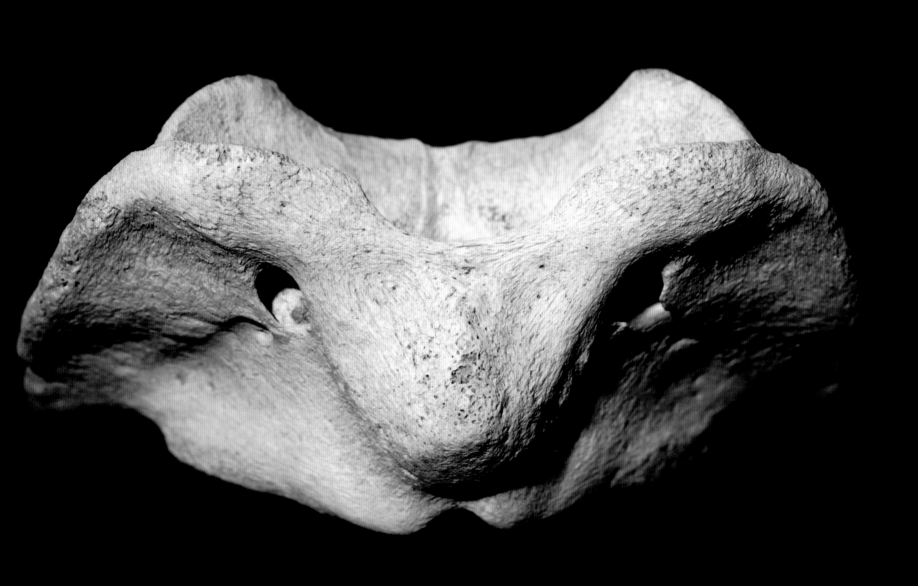

if you cannot dance with **BONES** *you are a nihilist*

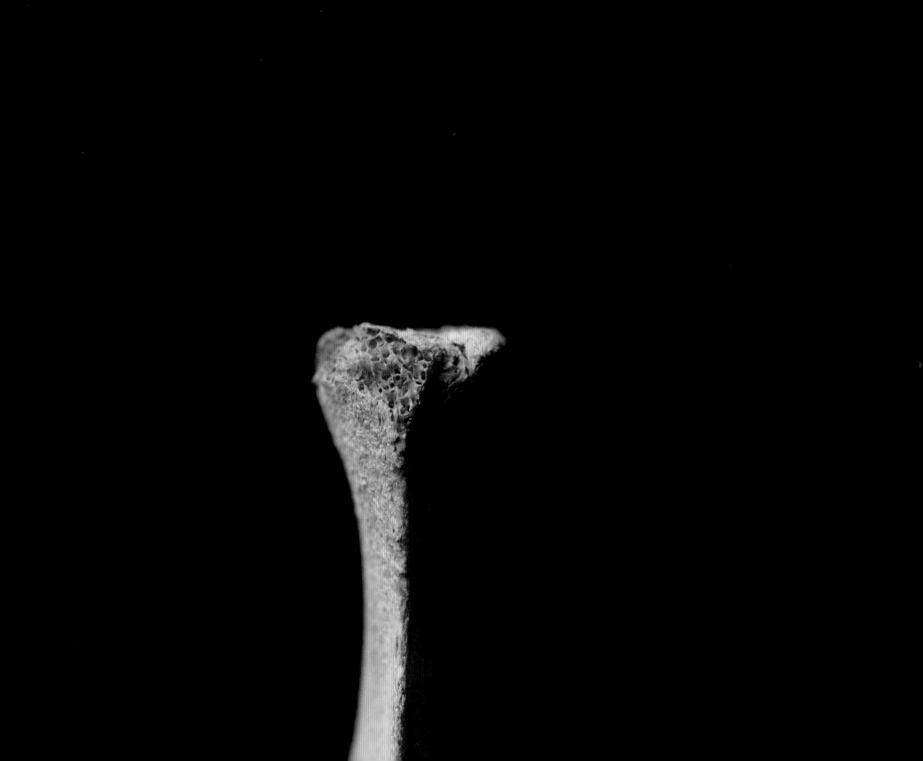

if bones are not beautiful, **THE INCARNATION IS A LIE**

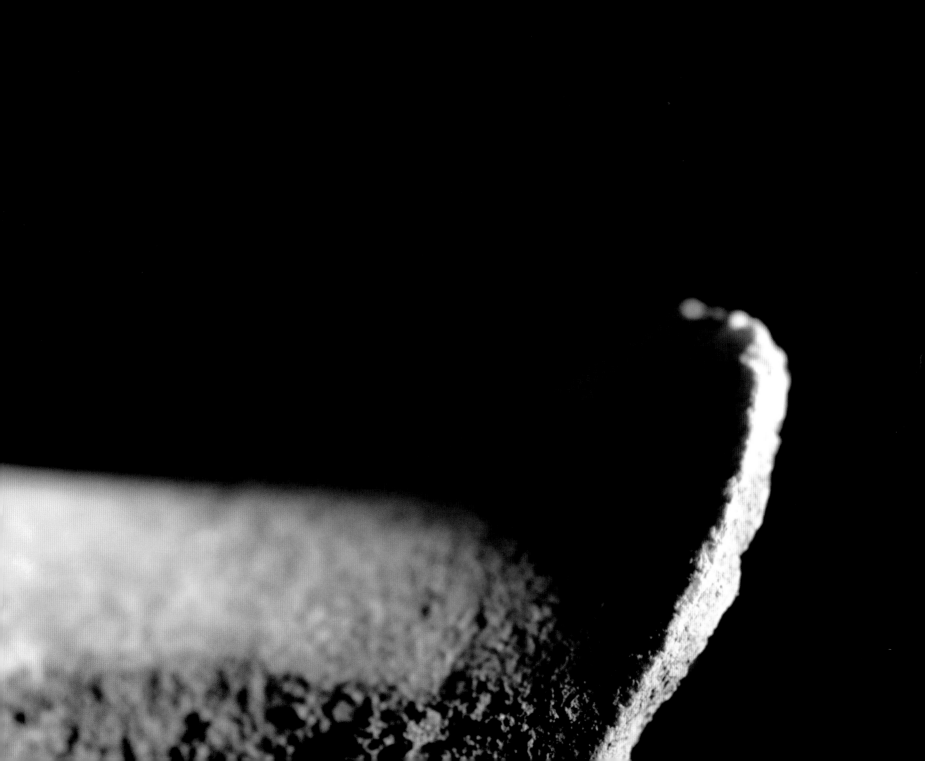

IN THE DESERT, NOTHING IS SACRED

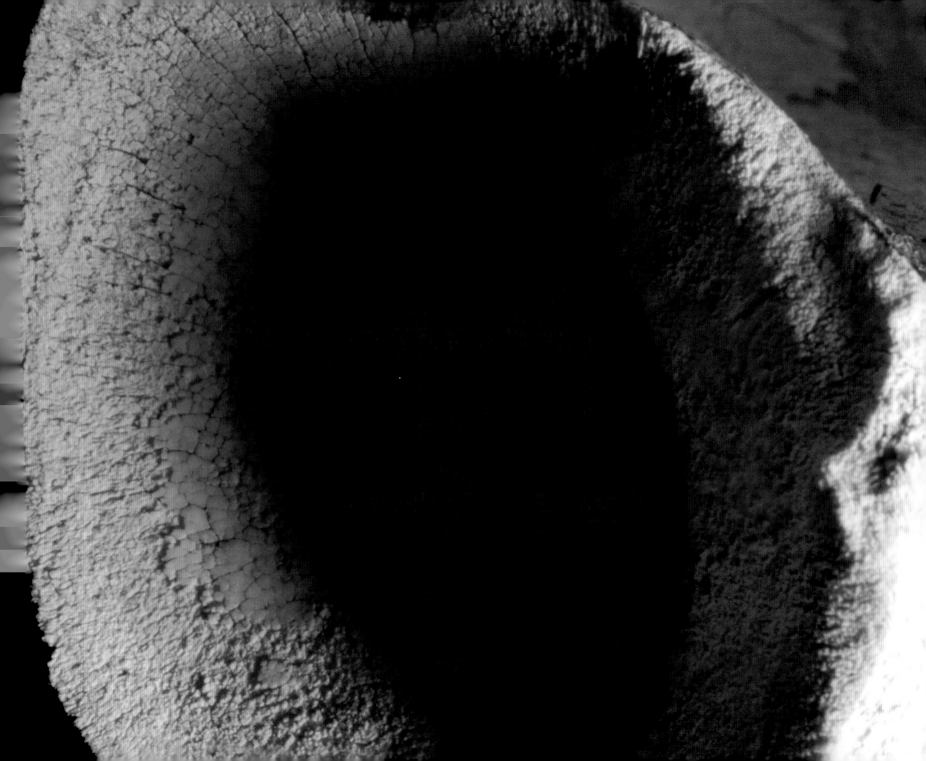

ACKNOWLEDGMENTS

This book would not have been possible without the support of many friends and colleagues. This strange journey never would have begun without the generous hospitality of Michael Heizer and Mary Shanahan during my stay in the Nevada desert many years ago. When I was struggling to understand the new world of digital photography, Aida Laleian gave me invaluable guidance and support. Kyle Acebo spent long hours teaching me how to use new equipment that often seemed baffling. Sharron Macklin and Kristine Taylor helped me explore the seemingly endless possibilities created by PhotoShop. When I needed critical advice and rigorous criticism I turned to Jack Miles, Thomas Krens, and Linda Shearer. Only your best friends can tell you what you need to hear rather than what you want to hear. In moments of doubt, the interest of Anthony Calnek was always reassuring. Over the years, the support of Morton O. Schapiro and Thomas Kohut, as well as Williams College, have enabled me to do work I could have done nowhere else. As always, Margaret Weyers helps day in and day out in so many ways that no thank you can ever be sufficient. The skill with which Randy Petilos helps authors navigate the complexities of the publication process continues to amaze me. Without his savvy guidance, production would have stalled repeatedly. This project, like many others, never would have been realized without the interest, encouragement and support of Herbert Allen. For contributions—some of which he would probably rather forget—I remain in his debt. The images and design of this work would have been impossible without the collaboration of an extraordinary photographer and two remarkable designers.

Kevin Reilly is an unusually gifted photographer who quickly understood the vision in my mind's eye and helped me bring it to life. Stella Lee, who has a very special sense of style, showed me initial design possibilities I never could have imagined. Isaac Tobin created the final design of the book, enriching the interplay of word and image and fashioning a new display typeface especially for this project. Finally, a special word about Alan Thomas. Alan and I have worked together for more than twenty years and I can honestly say that much of what I have been able to do during that time would not have been possible without his support. No one I know in the publishing world has a deeper appreciation for the significance of the arts and humanities than Alan. Since *Mystic Bones* is, admittedly, an unusual work whose point is not immediately obvious, I was uncertain how Alan would respond. When I showed him our initial layout, he immediately understood the work and its place in the philosophy of culture I have been developing for more than three decades. More than an editor, Alan has become a trusted friend. With appreciation for what we have done together and in anticipation of what we have yet to do, I dedicate this book to him.

NOTES

1. Edmond Jabès, *The Book of Margins*, trans. Rosmarie Waldrop (Chicago: University of Chicago Press, 1993).
2. Robert Heizer and Martin Baumhoff, *Prehistoric Rock Art of Nevada and Eastern California* (Berkeley: University of California Press, 1962), 11.
3. See Mark C. Taylor and Dietrich Christian Lammerts, *Grave Matters* (London: Reaktion Books, 2002).
4. D'Arcy Wentworth Thompson, *On Growth and Form* (New York: Dover Publications, 1992), 1018.
5. I have drawn most of the information about the structure and function of bones from *The New Encyclopedia Britannica* (Chicago: Encyclopedia Britannica, 1991), 2:356–57, and John Currey, *Bones: Structure and Mechanics* (Princeton: Princeton University Press, 2002).
6. Richard Selzer, *Mortal Lessons: Notes on the Art of Surgery* (New York: Harcourt Brace, 1987), 52.
7. Joseph Henninger, "Bones," *The Encyclopedia of Religion*, ed. Mircea Eliade (New York: Macmillan and Free Press, 1987), 2:284.
8. *Joseph Beuys in America: The Energy Plan for Western Man,* ed. Carin Kuoni (New York: Four Walls Eight Windows, 1990), 142.
9. Ibid.
10. André Leroi-Gourham, *Treasures of Prehistoric Art* (New York: Abrams, n.d.), 112.
11. Georges Bataille, *Lascaux or the Birth of Art* (Switzerland: SKIRA, n.d.), 11.
12. D. N. Jha, *The Myth of the Holy Cow* (New York: Verso, 2002), 139–40.
13. Sir James Frazer, *The Golden Bough* (New York: Macmillan, 1963), 609.
14. Omar Khayyam Moore, "Divination—A New Perspective," *American Anthropologist* 59, no. 1 (1957): 70.
15. Mircea Eliade, *Shamanism: Archaic Techniques of Ecstasy* (Princeton: Princeton University Press, 1972), 159–60.
16. Mircea Eliade, *Yoga: Immortality and Freedom*, trans. Willard Trask (New York: Pantheon Books, 1958), 298.

17. B. Laufer concludes his highly informative article with the following observation: "Finally, there is a visible survival of the ancient custom still preserved in our language. German *kopf* ('head') corresponds to English *cup* (Anglo-Saxon *cuppe*), both being derived from Latin *cuppa* ('cup'). In Italian, *coppa* means a 'cup'; but in Provençal the same word in the form of *cobs* means a 'skull.' Latin *testa* refers to a pottery vessel or sherd, as well as to the brain-pan and head. In Provençal, *testa* signifies a 'nut-shell'; in Spanish, *testa* denotes 'head' and 'bottom of a barrel.' In Sanskrit, *kāpala* means both 'skull' and a 'bowl.' This correlation is still extant in many other Indo-European languages" ("Use of Human Skulls and Bones in Tibet," *Field Museum of Natural History*, Chicago, no. 10 [1923]: 24). I have drawn many details of Tibetan rituals from Laufer's informative study.

18. Ibid., 1.

19. Ibid., 13.

20. G. W. F. Hegel, *Phenomenology of Spirit*, trans. A. V. Miller (New York: Oxford University Press, 1977), 200, 197.

21. Philippe Ariès, *The Hour of Our Death*, trans. Helen Weaver (New York: Random House, 1982), 262, 61.

22. Friedrich Nietzsche, *The Birth of Tragedy*, trans. Francis Golffing (New York: Doubleday, 1956), 9.

23. Wallace Stevens, "Adagia," *Opus Posthumous*, ed. Samuel French Morse (New York: Random House, 1957), 178.

24. Martin Heidegger, *Poetry, Language, Thought*, trans. Albert Hofstadter (New York: Harper Books, 1971), 219.

25. Ibid., 174.

26. Friedrich Nietzsche, *Thus Spoke Zarathustra*, trans. Marianne Cowan (Chicago: Henry Regnery, 1968), 335.

27. Coleridge was intrigued by the German Idealist notion that the formative activity of the imagination unifies and integrates what otherwise remains dispersed. This is the nuance he stresses when he coins the word *esemplastic*. He explains that he constructed this term "from the Greek words εἰς ἕν πλάττειν, to shape into one; because, having to convey a new sense, I thought that a new term would both aide the recollection of my meaning, and prevent its being confounded with the usual import of the word, imagination." Coleridge was convinced that the human imagination cannot be understood unless it is seen as a moment in an activity that infinitely exceeds it.

28. Wallace Stevens, "Negation," *The Collected Poems of Wallace Stevens* (New York: Knopf, 1981), 97–98.